Dublin City Gallery The Hugh Lane

Dublin City Gallery The Hugh Lane

Edited by Margarita Cappock

HUGH LANE
dublin

Dublin City Council
Comhairle Cathrach Bhaile Átha Cliath

MERRELL
LONDON · NEW YORK

In memory of
DERMOT FURLONG
Head Attendant
from 1988 *to* 2005

Contents

Author abbreviations:

Margarita Cappock MC
Patrick Casey PC
Barbara Dawson BD
Georgina Jackson GJ
Christina Kennedy CK
Jessica O'Donnell JO'D
Joanna Shepard JS

Foreword

Dublin City Council celebrates the opening of Dublin City Gallery The Hugh Lane's new extension with this publication. Hugh Lane gifted his renowned collection to Dublin in 1908 and it has always been regarded by the city as the jewel in its crown of cultural assets. As well as significantly enhancing the Gallery, this new extension, designed by Dublin-based architects Gilroy McMahon, is also a tangible recognition by Dublin City Council of the substantial contribution the creative arts bring to the life of the city. We are fortunate that so many artists have made Dublin their home and we can experience at first hand the ongoing innovation and excellence of their work. With these new spaces the Gallery is now in a position to make an even greater contribution to the appreciation of visual art practice and encourage a greater participation in its programmes by all of our audiences. We are particularly proud of our Children's Resource Centre and exhibition space, which underpins our ongoing commitment to our local communities and throughout the city with our off-site education projects, as well as our in-house workshops and art classes.

In keeping with Council policy on the visual arts, the Gallery's cultural remit extends beyond its structural boundaries with site-specific installations throughout the city. In celebration of the completion of the O'Connell Street project and the initiation of the Parnell Square regeneration plan, the city is proud to host an outdoor exhibition of sculpture by Barry Flanagan, now an adopted Dubliner, in June 2006.

This book highlights a selection of the treasures of the city's collection, including recent acquisitions and the Hugh Lane Bequest paintings, which are shared with the National Gallery, London. As part of the celebrations for the opening, we are delighted to have on special loan all eight Impressionist paintings

from London. We are extremely grateful to Dublin-born Sean Scully for his generous donation of superb paintings, which will hang in the new wing. The Chairman of the board, Ann Reihill, and the trustees have worked tirelessly and successfully in raising funds for desired acquisitions and their efforts and the generosity shown by some visionaries in our business communities is much appreciated

Congratulations to Barbara Dawson, Director of the Gallery; Margarita Cappock, Head of Collections, who edited this publication; Patrick Casey, Georgina Jackson, Christina Kennedy, Jessica O'Donnell and Joanna Shepard, whose contributions to this book have enriched our appreciation and understanding of this great collection; also to Liz Forster, who organized copyright for the reproductions, and John Kellett, whose photographs greatly enhance the book. Thanks also to Dennis Bailey, the book's designer, and to Merrell Publishers, in particular Hugh Merrell, Nicola Bailey, Anthea Snow, Helen Miles and Sadie Butler.

The Department of Arts, Sport and Tourism has co-sponsored the publication and our sincere thanks goes to Minister John O'Donoghue, TD, for his support.

John Fitzgerald
City Manager

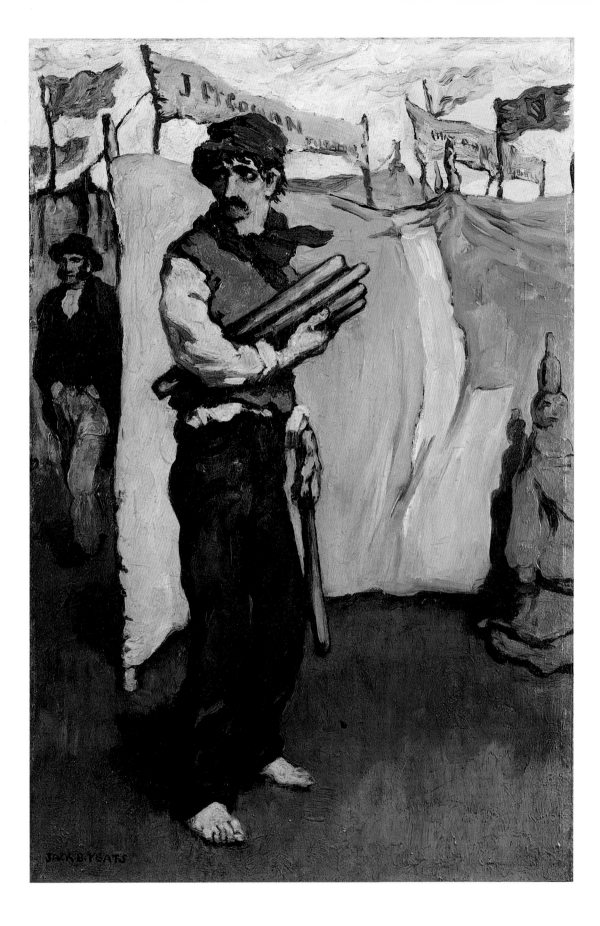

The Hugh Lane revisited

"The project of founding a Gallery of Modern Art for Ireland is no longer an idea, it is now an accomplished fact."

Sir Hugh Lane, Dublin, December 1907

Dublin City Gallery The Hugh Lane first opened its doors on 20 January 1908 as The Municipal Gallery of Modern Art with an acclaimed collection bought by Hugh Lane and his supporters. The collection also included some works presented by artists sympathetic to Hugh Lane's vision, Roderic O'Conor and Jack B. Yeats among them. In the spirit of great Victorian philanthropy, the collection was donated to the city and, along with the Abbey Theatre, founded in 1904, it became an iconic cultural institution of the new century. The Gallery's future direction was clearly outlined by the collection presented, which included works by the French Impressionists Manet and Degas, as well as other leading Irish and European contemporary artists. It is now believed to be among the first galleries of modern art, if not the first. (Ironically, the Tate Gallery, which originally opened as the National Gallery of British Art, was formally constituted as the National Gallery of Modern Foreign Art in 1917 as a result of the controversial Sir Hugh Lane Bequest, which formed the basis of its foreign collection.) This conditional gift of thirty-nine French paintings was contingent on Dublin building a gallery to house the entire collection. The works were moved to the National Gallery, London, by Hugh Lane in 1913, following a dispute with the Dublin Corporation over the site and architect for the building. Lane made a will leaving them to London, but after his appointment as director of the National Gallery of Ireland in 1914, he relented and wrote a codicil to his will returning them to Dublin. The codicil was signed but not witnessed and was successfully contested by London after Lane's death aboard the liner *Lusitania* in 1915. However, an agreement is now in place whereby the paintings are shared by the two

institutions in a rotating arrangement, and in recognition of the success of this unique agreement all eight Impressionist paintings from the Lane Bequest will be loaned by the National Gallery, London, on special exhibition at the opening of the Gallery's new wing this year. It will be the first time the paintings will hang together in Dublin since 1913.

The Gallery is significant not only because of its collection of international art, but also for its association with twentieth-century literature, in particular the Nobel laureate William Butler Yeats (1865–1939). W.B. Yeats recalls the controversy, disappointments and eventual joy in the permanent location of the collection in Charlemont House in a number of poems, including the wonderfully titled 'To A Wealthy Man Who Promised A Second Subscription To The Dublin Municipal Gallery If It Were Proved The People Wanted Pictures' (September 1913) and the poignant 'The Municipal Gallery Revisited'.

Hugh Lane's extraordinary vision to donate a collection of modern art to Dublin was inspired by the successful activities of the members of the Celtic Revival, who included his aunt Augusta Lady Gregory and W.B. Yeats (founders of the Abbey Theatre), Douglas Hyde and Edward Martyn. They championed the revival of Irish literature and folklore, and supported contemporary writers, in particular playwrights whose work they performed in the Abbey Theatre. Recalling the renown of contemporary Irish writers, Hugh Lane wrote: "There is something of common race instinct in all original Irish writers of to-day, and it can hardly be absent in the sister art." And in an astonishing and passionately productive seven years, from 1901 when he first met Yeats with Lady Gregory in Coole Park, to the opening of the Gallery in 1908, he amassed a collection described by *Le Figaro* as "an entire museum rich in beautiful works, a museum envied by the most prosperous states and the proudest cities" (20 March 1908). This original collection of three hundred works is an important microcosm of the prevailing aesthetics of the time. In its evolution it continues to represent the

concerns of artists, and as we look through the work of the artists represented here, a fascinating story of visual art in Ireland unfolds. While there is an excellent representation of the main issues pre-occupying artists and in particular Irish artists over the last century, the collection is not representative of all manifestations.

Until 1991, when the Irish Museum of Modern Art was established, the Hugh Lane Municipal Gallery of Modern Art was responsible for the national collection of modern art. Considering it did not have a purchasing budget until 1974, the wealth of art works the Gallery houses is remarkable. The collection was dependent on donations and bequests, many of which are extremely prestigious. In 1935 John Lavery presented the Lady Lavery Memorial Bequest, which comprises thirty-six works, including the historically significant portraits of the signatories of the Irish Treaty. All are painted by John Lavery, apart from a unique portrait of the artist by his wife. In 1924 the Friends of the National Collections of Ireland was established and soon came to the conclusion that it should devote its energies to acquiring works for the City Gallery. Through its efforts works by such artists as Pierre Bonnard, Georges Rouault, Maurice de Vlaminck, Josef Albers, Henry Moore and Berthe Morisot entered the collection. The Contemporary Irish Art Society, founded in 1962, was instrumental in ensuring the ongoing evolution of the contemporary collection. Incredibly, as late as the 1960s the CIAS was the only institution in the country dedicated to the support of living Irish artists, and it presented important works by leading Irish artists, the first being *Large Solar Device* by Patrick Scott. More recently, the business community has assisted in sponsoring exhibitions and acquisitions, for which we are extremely grateful. However, in viewing the collection in its entirety, the lack of a disciplined coherency in the absence of an adequate purchasing grant is evident. The collection's identity has been established as that of a hybrid. This we now celebrate, as out of this discrepancy a singular pattern has evolved in that the work of a small group of artists, or an in-depth collection of one artist's work, continues to represent and elucidate wider concerns.

In the past decade this has been emphasized by two outstanding acquisitions. In 1998 the Gallery received the prestigious donation of Francis Bacon's Studio, originally situated in 7 Reece Mews, South Kensington, London. This gift, made by the late John Edwards, came about through the advice of Brian Clarke, his friend and adviser and executor of the Estate, whose determination to preserve the studio ensured its successful relocation to Dublin. The Gallery's active pursuit of the donation as a desired catalyst for the collection was given further credence by Francis Bacon's having been born in Dublin. It also presented the Gallery with a very welcome challenge not only to put together a team that would catalogue, pack, transport and relocate every item in the studio to Dublin, but also to create, in museum practice, a pioneering and unique centre of investigation. This has been one of our proudest achievements in recent years. The subsequent acquisition for the Gallery, by Tedcastle Holdings (Fuel Importers) and other enlightened supporters, of six unfinished paintings from the Estate furthers the investigation. One of the greatest post-war artists, Francis Bacon's figurative expression follows in the tradition of great European painting.

As a result of an ongoing collaboration with Sean Scully, who like Francis Bacon was born in Dublin, the Gallery is honoured to be the recipient of a gift of seven paintings, promised since the mid-1990s and presented by the artist this year. These paintings form the second permanent installation in a dedicated gallery in the extension. This gift from Sean Scully, a superb exponent of abstract art, provides a mainstay for the varied exponents of non-figurative painting in the collection; his practice is singular in its illumination of contemporary concerns in abstract expression.

The particular vision of the Gallery has also been brought forward with the acquisition of eight significant works, made possible through generous donations raised by our chairman and board of trustees. The donors include Anglo-Irish Bank. Two projected film works, *Ivana Answers* and *The Actress*, by Jaki Irvine begin to

redress the imbalance in that area of the collection, *Clara and Dario* by James Coleman, purchased in 1986, being the sole work in this medium in the collection until now. Matt Calderwood's video *Screen*, a site-specific projected film made for our exhibition 'Clarke and McDevitt Present', transforms a blank gallery wall into a rural Irish landscape in a way that is both amusing and disconcerting. *The dene 'vignette'* by Niamh O'Malley is an innovative response to the nineteenth-century Greensward design for Central Park, New York, in painting and video; and *Why It's Time for The Imperial Again* by Gerard Byrne charts, through an installation of film and photography, the historic gap from what was luxurious and technologically advanced twenty years ago when the Chrysler Imperial was launched, to the fetishes of contemporary consumerism. A new work by Elizabeth Magill, *Greyscale*, significantly contributes to our contemporary reading of figurative painting. *The Big House* and *Jail Visiting* by Brian Maguire also bring forward the representation of figurative expression in the collection. These two large evocative works, together with *The Foundation Stones (Mental Home)*, purchased in 1993, complete a suite of works exploring society's attitudes and behaviour towards marginalized communities.

During 2005 a select few visionaries from the business community, including Tedcastle Holdings (Fuel Importers), Patrick McKillen and Patrick and Helen Conlan have given huge support for the new extension with donations that significantly address certain gaps in the collection and contribute to its international renown. *Outskirts* by Philip Guston, in one work, successfully provides the transition from the celebrated Irish tradition of figurative painting through to the great Bacons and on to a younger generation of Irish artists. *Black Relief over Yellow and Orange* by Ellsworth Kelly, another acclaimed exponent of abstraction, complements our Agnes Martin, *Untitled No. 7*, purchased in 1980. This pairing centres the Agnes Martin work, which has, until now, hung without context and helps to clarify the concerns of these two great influential artists. Together they thread through our collection of non-figurative art,

providing the basis of a continuum through to the paintings of Sean Scully and the next generation of abstract expressionists. *Wall of light Sky* by Sean Scully is a welcome addition to the Sean Scully collection, and *Crow* by Seán Shanahan also makes a singular contribution to the Gallery's story of contemporary abstract painting.

The Gallery's new extension marks a watershed in its history. These new civic spaces, built by the City Council for Dubliners and visitors to the city, demonstrate the Gallery's increased responsibility in making an ongoing and relevant contribution to the appreciation of visual art practice and reconfirm it as an autonomous centre of investigation and research.

Barbara Dawson
Director
March 2006

The Collection

John Constable

b. East Bergholt, Suffolk, 1776 – d. London, 1837

Brighton, July 20th 1824
1824
Oil on cardboard
22.2 × 38.1 cm
Presented by the
Earl of Dunraven, K.P., 1905
Reg. No. 543

John Constable sought to portray the English countryside in all its wildness, transience and beauty. Throughout his career he painted out of doors, making small, rapidly executed sketches that he would also occasionally annotate with precise details of dates, times and weather conditions. These works provided Constable with a rich visual archive on which he would draw, sometimes many years later, when working on large landscapes completed in his studio. Constable predominantly painted the landscape of his native Suffolk, as well as around Hampstead, north London, where he lived from 1827. In 1816 he had married Maria Bicknell. When his wife was diagnosed with tuberculosis the couple made several trips to Brighton where, it was hoped, the sea air would help relieve her symptoms. Although the fashionable sea resort was not to his taste, Constable made a number of drawings and oil sketches of Brighton and its coastline and this precisely dated work, depicting a storm-laden sky, was made shortly after his first visit there in May 1824. This year proved momentous for Constable, since his most famous work, *The Hay Wain* (1821; The National Gallery, London), was awarded the gold medal at the Paris Salon, reflecting the high esteem with which his work was held in France.

JO'D

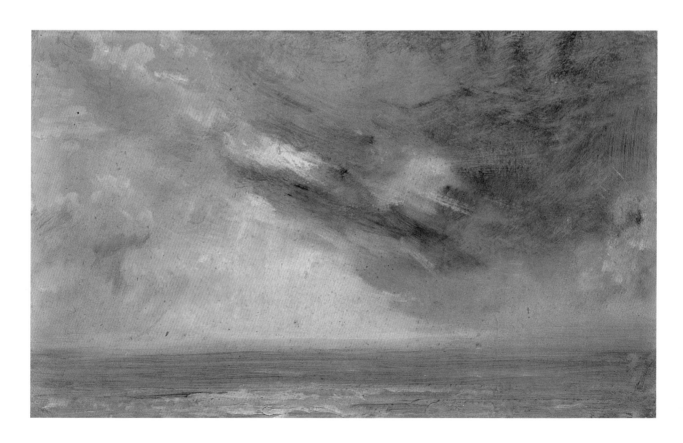

b. Paris, 1796 – d. Paris, 1875

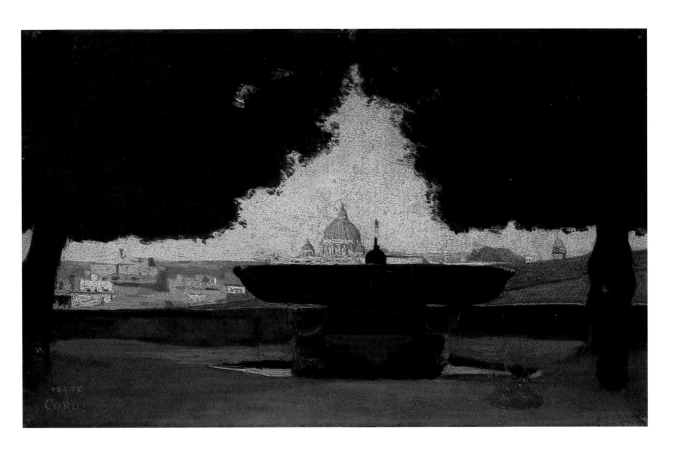

Rome from the Pincio

1826–27
Oil on canvas
18 × 29 cm
Signed lower left, *Vente Corot*

Purchased through subscriptions
collected by Rose Mary Barton,
1905
Reg. No. 550

Jean-Baptiste-Camille Corot travelled to
Rome in 1825 and remained there until
1828, during which time he made several
atmospheric observations of the city and
its environs. A preparatory drawing for
this work is in the Louvre, Paris, and there
are three other versions of the painting,
all painted between 1826 and 1827; the
most finished version is in the Musée
Departmental de l'Oise, Beauvais. The
Hugh Lane painting is less defined but is
nonetheless a masterpiece in its own right.
Although Corot depicts the fountain basin in
the immediate foreground with the cupola
of St Peter's behind, it is in fact an idealized
scene, since it is not possible to see this
particular view from the Villa Medici. In
order to achieve a Classical harmony in
the composition, Corot has substituted the
spout of the fountain for the obscured dome
of the basilica. The viewpoint is low and he
places the dome above the horizon line. The
figure of a priest can be discerned in front of
the tree on the right. This work is also an
excellent study in light and shade, with the
light radiating from the middle section of
the work. Corot's master, Achille-Etna
Michallon, had painted the same fountain,
albeit from a different angle.

MC

Gustave Courbet

b. Ornans, France, 1819 – d. Vevey, Switzerland, 1877

The Diligence in the Snow

1860
Oil on canvas
137.2 × 199.1 cm
Signed and dated, lower left, *G. Courbet 60*

Sir Hugh Lane Bequest, 1917;
on loan from The National
Gallery, London, since 1979
Reg. No. NG 3242

Gustave Courbet was born to affluent parents, but retained an affinity for their rural origins. At the age of twenty, defying his family's wishes that he should study law, he moved to Paris to become an artist, studying under M. Steuben, now obscure, and copying Old Master paintings in the Louvre. From the early 1840s he offended critics by painting genre scenes of contemporary life on the monumental scale, then reserved for historical or mythological subjects, and emerged as the head of a new school of painting known as Realism.

Commercial success did not come until the 1860s with more popular, smaller-scale still lifes and nudes, and such landscapes as *The Diligence in the Snow*, thought to derive from an accident Courbet witnessed while on a hunting trip near his birthplace. A 'diligence' was a type of commercial stagecoach and the main form of long-distance transport before the emergence of the railways. Courbet shows the coach overturned in snowdrifts so deep and sculpted that they resemble a stormy sea, the small figures dwarfed by the expansive landscape setting. The brooding sky heightens the sense of drama and the isolation of the struggling group, despite the presence of the dwelling in the middle distance.

JS

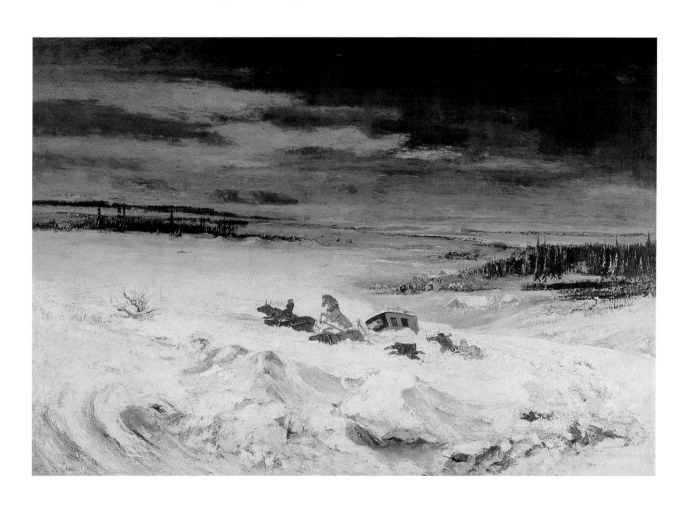

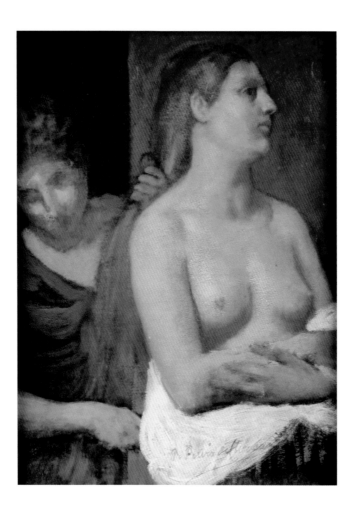

La Toilette (A Maid Combing a Woman's Hair)

c. 1878–83
Oil on millboard
32.5 × 24 cm
Signed lower right,
P. Puvis de Chavannes

Sir Hugh Lane Bequest, 1917; on loan from The National Gallery, London, since 1979
Reg. No. NG 3267

The theme of a woman at her toilet was one that clearly appealed greatly to Pierre-Cécile Puvis de Chavannes, as the large number of representations of this subject attest. This particular sketch relates to a larger painting of 1883, which is in the Musée d'Orsay, Paris. The motif of a semi-clad woman having her hair combed featured prominently in the work of fellow French artist Edgar Degas (see pp. 26–28). However, both artists divested their works of the traditional narratives normally associated with this subject, which focus on such figures as the mythological goddess of love, Venus, or the biblical Esther.

In this small, tightly focused work, the two figures are standing and seen close up. There is very little perspective recession, lending the work a quality that is reminiscent of Italian primitive wall paintings, which the artist admired. The figures are placed in a plain, uncluttered space, and the simple contours and subdued colour scheme contribute to the overall atmosphere of serenity and intimacy. There is no sense of connection between the main female figure, who appears engrossed in her own thoughts, and the secondary female figure, who is not as technically finished as the woman having her hair combed.

Puvis de Chavannes achieved great fame in the second half of the nineteenth century through his mural paintings, many of which can be found in public buildings in France.

MC

Camille Pissarro

b. Paris, 1830 – d. Paris, 1903

View from Louveciennes

1869–70
Oil on canvas
52.7 × 81.9 cm
Signed lower right, *C. Pissarro*

Sir Hugh Lane Bequest, 1917; on loan from The National Gallery, London, since 1979
Reg. No. NG 3265

This landscape is one of the finest extant examples of Camille Pissarro's earlier work. It was probably painted in the spring of 1870. The previous year Pissarro had moved from Pontoise to Louveciennes, a village a few miles west of Paris, where fellow Impressionists Renoir (see p. 34), Monet (see pp. 31–32) and Sisley were then active. Louveciennes overlooks the Seine and is close to the forest and park of Marly-le-Roi.

One of the characteristics of Pissarro's work is a sense of place, and he repeatedly analysed the same motif, looking at a scene from different angles. In this painting, Pissarro depicts the village of Voisins in the centre and the road leading towards the remains of the Marly aqueduct on the left horizon. Louveciennes itself is outside the field of vision, on the left.

A preoccupation with human interaction with the natural world is another characteristic of all of Pissarro's work.

This is evident in this painting in the inclusion of some of the inhabitants of the village walking towards the aqueduct. These figures also serve to emphasize the directional flow of the road and lead the viewer's eye into the composition.

Pissarro exhibited in all eight of the Impressionist exhibitions. Hugh Lane bought this painting in around 1906 from the Parisian dealer Paul Durand-Ruel for £500.

MC

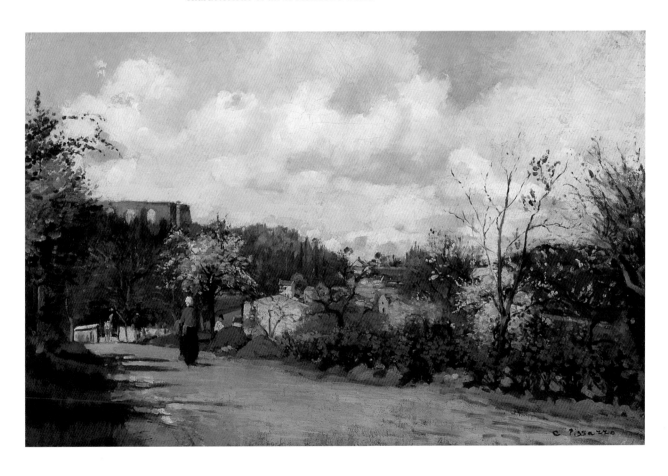

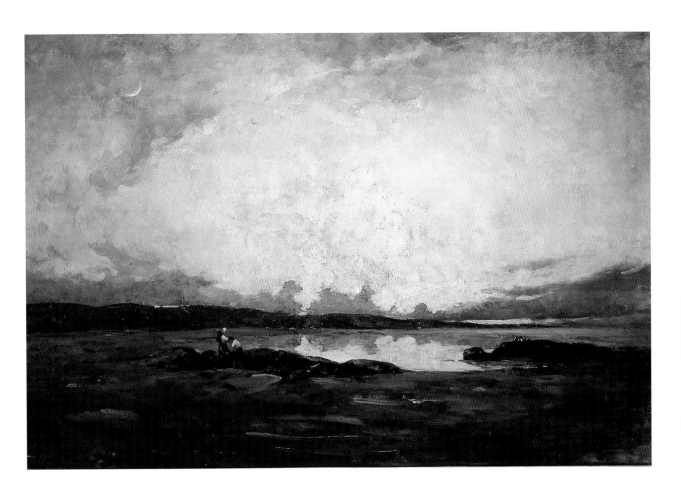

Evening, Malahide Sands

c. 1885
Oil on canvas
85 × 126 cm
Signed lower right,
Nath. Hone R.H.A.

Presented by the artist, 1904
Reg. No. 206

Nathaniel Hone was Ireland's first great naturalistic painter. His departure for Paris in 1853 marked a turning-point in Irish art and he was the first Irish artist of significance to study in France, where he spent eighteen years. Although painted in Ireland, *Evening, Malahide Sands* shows the impact of Hone's time in France with the Barbizon school of naturalistic painters, in particular, Jean François Millet, Corot (see p. 17) and Henri Harpignies. He produced several versions of this scene but this work is widely recognized as one of his great paintings. Like most of Hone's works it is undated, but it was exhibited at the Royal Hibernian Academy, Dublin, in 1883 and is generally thought to date from the early 1880s.

Hone lived near Malahide and knew this stretch of beach very well. In the lower left foreground, a young boy and girl gather seaweed. In the distance on the right, a group of oyster-catchers is perched on the rocks. The grey and brown tonalities of the land are enlivened by the touches of white, mauve and pale yellow. Hone excelled at painting the sky. In this work, the sun has set and the last of the sunlight is reflected on the clouds; a crescent moon rises in the sky, contributing to the air of stillness. Hone presented this painting to Hugh Lane in 1904, when Lane was starting a collection for a gallery of modern art in Dublin.

MC

Edouard Manet
b. Paris, 1832 – d. Paris, 1883

La Musique aux Tuileries

1862
Oil on canvas
76.2 × 118.1 cm
Signed and dated, lower right, *éd Manet 1862*

Sir Hugh Lane Bequest, 1917;
The National Gallery, London
Reg. No. NG 3260

In *La Musique aux Tuileries*, Edouard Manet, who is regarded as the father of Modernism, made his first real attempt at capturing contemporary urban life. A crowd of well-to-do Parisian bourgeoisie is gathered in the gardens of the Tuileries Palace to enjoy the twice-weekly concert: it was the perfect opportunity for Manet to sketch his literary, artistic and musical friends. These included the poet Charles Baudelaire, whose views on the 'heroism' of modernity so encouraged him. When first exhibited in 1863 *La Musique aux Tuileries*, with its lack of polish and its bold brushwork, shocked and infuriated the public.

Manet has depicted himself standing on the extreme left. Next to him is the painter Albert de Balleroy, with whom he had shared a studio, and just visible between them may be the writer Champfleury. Seated to their right is the sculptor and critic Zacharie Astruc. The two women wearing blue bonnets and seated in the foreground may be Madame Loubens (veiled) and Madame Lejosne. Directly behind the latter is the profile of the poet Baudelaire and over his shoulder, facing out, is the bearded face of the painter Henri Fantin-Latour. The prominent standing figure right of centre is Manet's brother Eugène, while the spectacled seated figure to his right is the composer Jacques Offenbach. The centrally placed auburn-haired child is Leon Leenhoff, Manet's godson and probably also his natural son.

CK

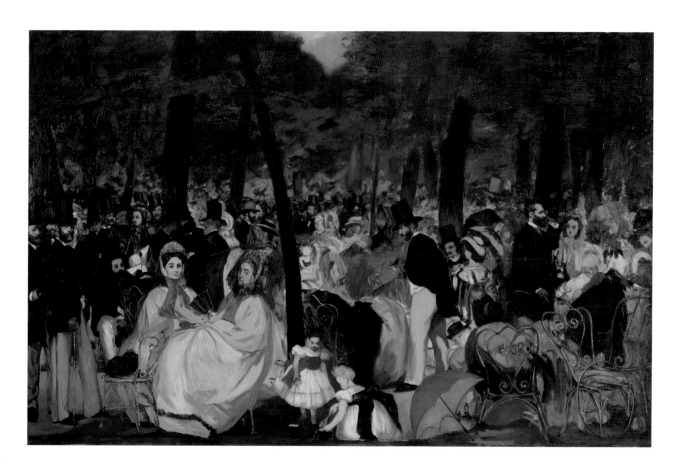

b. Paris, 1832 – d. Paris, 1883

By 1908 Hugh Lane had earned a reputation as one of the first and most well-known collectors of Impressionist art outside of France. As D.S. McColl (then Keeper of the Tate Gallery) observed, Lane "with knowledge and courage and no great amount of money did in a year or so what official buyers will now find it difficult to do at all". He was speaking in the wake of Lane's purchase of Edouard Manet's *Eva Gonzalès* and *La Musique aux Tuileries* (see p. 22) in 1906. *Eva Gonzalès* was already familiar to Irish audiences, having been included in a loan exhibition organized by Lane in 1904 when seeking support for his proposed gallery of modern art for Dublin.

Eva Gonzalès was an accomplished painter, pupil and friend of the artist. In this large portrait, painted for the 1870 Salon, she is seated at her easel. Manet, who revelled in the fabrics and forms of women's fashions, shows her resplendent in a white dress. He had to rework the face repeatedly, perhaps because of his sitter's distinctive nose. Later in 1870 Manet corresponded with Gonzalès in Dieppe while he fought as a volunteer gunner in Paris during the Franco–Prussian War. Gonzalès married Henri Guerard in 1879 but died in 1883 after giving birth, within a few days of Manet himself.

CK

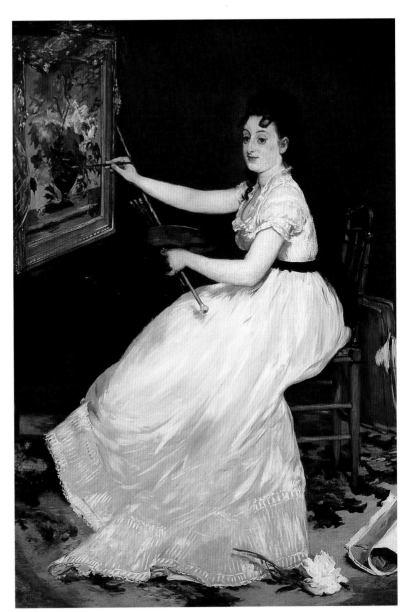

Eva Gonzalès

1870
Oil on canvas
191.1 × 133.4 cm
Signed and dated, lower right,
Manet 1870

Sir Hugh Lane Bequest 1917; on loan from The National Gallery, London, since 1979
Reg. No. NG 3259

Edward Burne-Jones
b. Birmingham, 1833 – d. Fulham, London, 1898

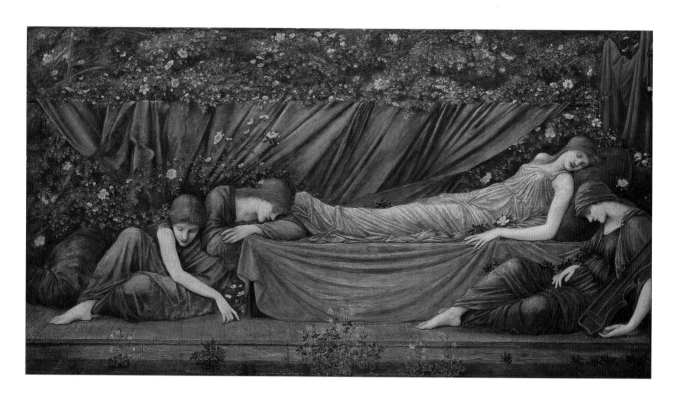

The Sleeping Princess
c. 1872–74
Oil on canvas
126 × 237 cm
Signed and dated lower left,
E.B.J. 1872–74

Lane Bequest, 1913
Reg. No. 113

Edward Burne-Jones and William Morris, his fellow student at Oxford and with whom he was to collaborate on numerous decorative commissions, both abandoned their religious studies to pursue careers in the arts. With the encouragement of John Ruskin, Burne-Jones studied Venetian painting and Early Renaissance masters during numerous travels to Italy. The Pre-Raphaelite painter Dante Gabriel Rossetti was also an important influence.

Burne-Jones was an imaginative, romantic and predominantly self-taught artist who painted his subject-matter, drawn from literary, historical and mythical sources, in an original, often evocatively wistful manner. *The Sleeping Princess* is one of a number of paintings inspired by *The Legend of the Briar Rose* that Burne-Jones painted between around 1871 and 1894, and it reveals his love of challenging compositional arrangements stemming from the use of horizontal or vertical canvases. This work differs from his other versions of *The Sleeping Princess* in its restrained, verdant colour tones and the inclusion of

an hour-glass, which emphasizes the passage of time and the legend's underlying theme of the transition from girlhood to womanhood. In 1890 paintings from the Briar Rose series were shown to critical acclaim at Agnew's, his art dealers in London, marking the apotheosis of his career.

JO'D

b. Lowell, Massachusetts, 1834 – d. London, 1903

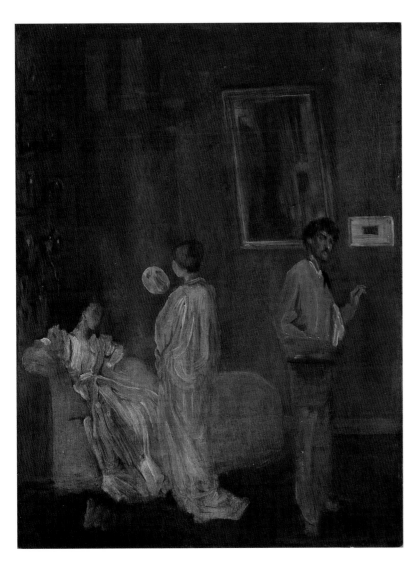

The Artist's Studio

1865
Oil on cardboard
62.2 × 46.3 cm

Lane Gift, 1912
Reg. No. 6

James Abbott McNeill Whistler was in the vanguard of the fashion for Japanese art that developed in Europe during the early 1860s. He was especially influenced by Japanese woodblock prints, or *Ukiyo-e*, and developed a highly aestheticized approach to painting, characterized by flatness of composition and tonal harmonies of thin liquid oils and calligraphic brushstrokes. In particular, his views of the River Thames evince vestiges of forms and moody vistas on the verge of dissolution with an indeterminacy that presages elements of twentieth-century Abstraction.

The Artist's Studio is one of two preliminary studies for a monumental painting intended to include Henri Fantin-Latour and Albert Moore, but which was never realized. The other sketch, which is almost identical but more defined, is in The Art Institute of Chicago. Featured with the artist are his Irish model and mistress, Joanna Heffernan, and a figure in a kimono whom Whistler referred to as 'La Japonaise'. Dressed in his customary long-sleeved waistcoat, the artist holds a palette with raised edges to contain the liquid paint. The elongation of the figures, play of shapes and monochrome, uncluttered surroundings recall such Japanese masters as Hokusai and Utamaro. Glimmering in the background is a display of the artist's famous collection of Oriental blue-and-white porcelain, which he occasionally incorporated in his paintings.

CK

Hilaire-Germain-Edgar Degas
b. Paris, 1834 – d. Paris, 1917

Thoroughbred Horse, Walking

1865–81
Bronze
13 × 10 × 21 cm

Mrs J.H. Twigg Bequest, 1937
Reg. No. 808

Dancers and horses, with their supple bodies and graceful movements, were the subject-matter for nearly all of Edgar Degas's sculpture. They were his conduit to a unique transparency of form and movement, which was manifest in his entire œuvre. *Thoroughbred Horse, Walking* is part of a series of sculptures exploring physical automation. Such manifestations of movement were aided by his study of photography, in particular that of Eadweard Muybridge (1830–1904), whose photographs of horses in motion first appeared in Paris in 1878 in the December edition of *La Nature*. Because Degas was so secretive about his sculpture it is difficult to date *Thoroughbred Horse, Walking*, but it was probably modelled sometime before 1881. In this small, beautifully realized work he celebrates the renowned athleticism of the racehorse: movement and form are emphasized by the exposed spinal cord, which is central to the locomotive prowess of the thoroughbred. Of all of the sculpture found in Degas's studio, seventy-three pieces were cast in bronze by the founder A.A. Hebrard, each in an edition of twenty-two, of which those listed A to T were for sale. The remaining two were reserved for the founder and the heirs of the artist. This sculpture is marked G.

BD

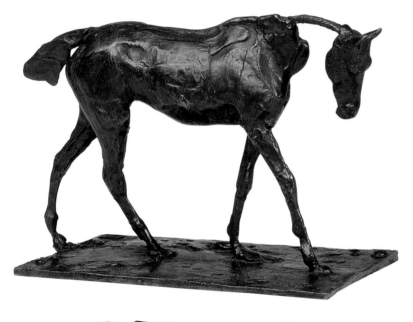

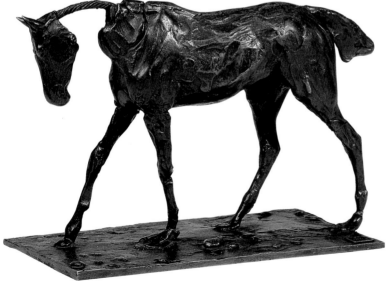

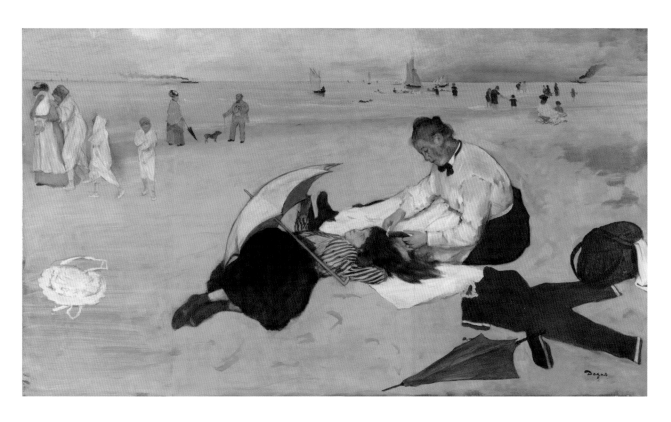

Sur la Plage (Beach Scene)

c. 1869–70

Oil (essence) on paper; three
pieces mounted on canvas
47.5 × 82.9 cm
Signed, lower right, *Degas*

Sir Hugh Lane Bequest, 1917;
on loan from The National
Gallery, London
Reg. No. NG 3247

Many of Edgar Degas's great paintings result
from his observations out of doors: urban
life in Paris; on the racecourse; and in this
case on the beach (Degas preferred taking
public transport, remarking that on the
omnibus he could see people). The resulting
works are just as acute and penetrating as
his ballet scenes and 'keyhole' views of
women's ablutions. Most probably painted
in his studio, *Sur la Plage* does not have the
atmospheric '*en plein air*' feel that pervades
the beach scenes of his contemporaries,
such as Claude Monet (see pp. 31–32) and
Eugene Boudin. The flattened figures owe
a debt to Japanese woodcuts, as does the
chopped frame, particularly around the bag
and umbrella. Masterly in execution, the
format echoes that of the *Ukiyo-e*, although
unlike the Japanese print, Degas has aligned
his sequences of images. The combining
influences of Oriental composition and
Western imagery have been embodied in a
revolutionary realism. This painting was
purchased for the Gallery by Hugh Lane in
around January 1913. In a letter to Lady

Gregory, W.B. Yeats wrote that Hugh Lane
"has just bought a Degas for £4,500 to go to
the Gallery if the money for the building is
found". The painting is now part of the Hugh
Lane Bequest, 1917, a collection of thirty-
nine works that is shared between the
National Gallery, London, and Dublin City
Gallery The Hugh Lane.

BD

Hilaire-Germain-Edgar Degas

b. Paris, 1834 – d. Paris, 1917

*A Peasant Woman
(A Young Woman in a White
Headdress)*

c. 1871
Oil on canvas
40 × 32 cm
Signed lower right, *Degas*

Purchased from the J. Statts
Forbes collection by a fund
collected by Mrs C.J. MacCarthy
for the Gallery in 1905
Reg. No. 547

A modern classicist, Edgar Degas lived and worked in Paris. Part of the revolutionary movements in painting championed by the Impressionists, he, like them, drew on contemporary life for his paintings. He exhibited in all the Impressionist exhibitions except that of 1882, but his work differs from theirs in that it displays no dissolution of form. He was a superb draughtsman, and his intensity of observation is apparent in all his work. While most famous for scenes of ballet and horse-racing, Degas imbues all his subject-matter with a startling realism.

A Peasant Woman is part of a small series of works in which he tackles the problems of painting white material against light, with its opposing qualities of transparency and opacity. The girl's white headdress is illuminated by the bright sunlight that pours in through a transparent white curtain. This painting also reveals Degas's preoccupation with *contre-jour*, modelling mass against light. This fluency of line assists his exploration of form and, with his innovative use of light and colour, he has created some of the most acute observations of contemporary existence.

BD

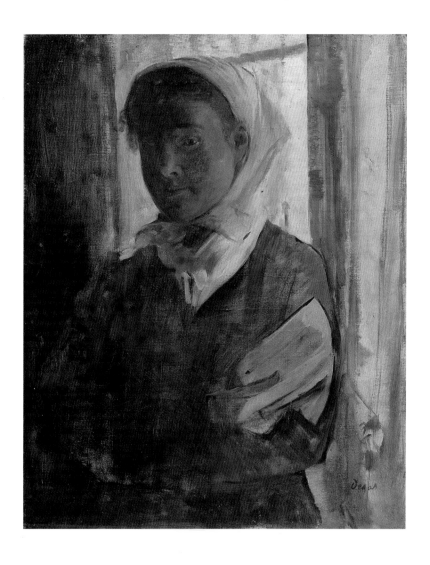

John Butler Yeats

b. Tullylish, County Down, 1839 – d. New York, 1922

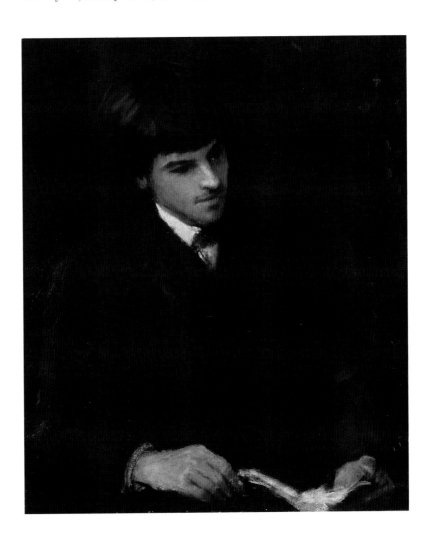

Portrait of
William Butler Yeats

c. 1886
Oil on canvas
76.6 × 64 cm

Lane Gift, 1912
Reg. No. 55

John Butler Yeats read Classics, Metaphysics and Logic at Trinity College, Dublin, graduating in 1862. The following year he married Susan Pollexfen, the sister of his schoolfriend George Pollexfen. Although called to the Bar in 1866, he moved to London with his family in 1867 to pursue a career as an artist. While portraiture was generally a lucrative genre, thereafter a life of financial uncertainty followed. In 1901 the artist Sarah Purser organized a groundbreaking exhibition in Dublin of his work and that of Nathaniel Hone (see p. 21), leading Hugh Lane to commission a somewhat reluctant Yeats to paint a series of portraits of distinguished Irishmen. The New York lawyer and collector John Quinn, an important supporter of Yeats when he moved to New York in 1907, also purchased a number of portraits from the exhibition. *Portrait of William Butler Yeats*, a painting of his son who was, at this time, an emerging poet, demonstrates Yeats's widely praised sensitivity in characterization. W.B. Yeats (1865–1939), shown here in youthful reflection, had attended the Metropolitan School of Art, since his father believed an art education provided a valuable foundation for life. He was also a vocal supporter of Hugh Lane and composed a number of poems, including *September 1913* and *The Municipal Gallery Revisited*, that were inspired by Lane's efforts to establish a gallery of Modern art, as well as the collection itself.

JO'D

Auguste Rodin

b. Paris, 1840 – d. Meudon, France, 1917

The Age of Bronze

1876–77
Original plaster work
Bronze
170 × 60 × 55 cm
Signed on base, lower right,
Rodin; on base, back, lower left,
Alexis Rudier, Fondeur à Paris

Lane Gift, 1912
Reg. No. 96

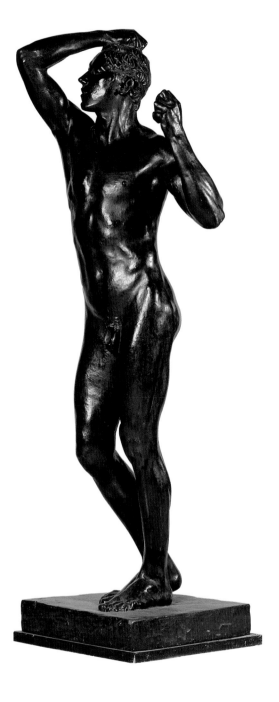

Auguste Rodin, the most celebrated French sculptor of his time, was turned down on three occasions for entrance to the Ecole des Beaux-Arts in Paris. Instead, he began his career as a commercial sculptor in the studio of A.E. Carrier-Belleuse. With the outbreak of the Franco–Prussian War, public commissions became scarce and Rodin went to Brussels for several years. There, he first received public recognition with this life-size nude, which he exhibited in 1877. The model for this work was a Belgian soldier named Auguste Neyt, and the work was first exhibited as *Le Vaincu (The Conquered Man)*, possibly a reference to the French defeat in the Franco–Prussian War in 1871. Originally the figure was holding a spear, which Rodin later removed. With Rodin, there is no attempt to idealize the figure, and this uncompromising naturalism led to controversy and allegations that it was cast from life when the work was exhibited at the Paris Salon under a new title, *The Age of Bronze*, a representation of one of the four ages of man as described by the ancient Greek writer Hesiod. Rodin had visited Italy in the winter of 1875, where he had sketched the works of the Renaissance masters Donatello and Michelangelo. This influence is much in evidence in the pose of the figure, which recalls Michelangelo's *Dying Slave* (*c.* 1513; Louvre, Paris).

MC

b. Paris, 1840 – d. Giverny, France, 1926

Lavacourt under Snow

c. 1878–79
Oil on canvas
59.7 × 80.6 cm
Signed and dated, *Claude Monet 1881*

Sir Hugh Lane Bequest, 1917;
The National Gallery, London
Reg. No. NG 3262

Traditionally, this painting was called *Vétheuil: Sunshine and Snow* but it is now believed to show Lavacourt, a hamlet on the other side of the Seine from Vétheuil, where Claude Monet lived between 1878 and 1881. Although dated 1881, this work was probably painted slightly earlier, possibly in 1878–79 since it is closer in style to other works executed during his first months in Vétheuil. The artist often signed his works long after completion, adding dates that were sometimes inaccurate. Monet's move to Vétheuil was the start of a period of isolation from the Impressionist group as he became disillusioned with its activities in the 1870s. At this time, Monet's financial situation was precarious and the artist and his family shared a house with a bankrupt former patron, Ernest Hoschedé.

Monet painted a number of similar views from the riverbank, looking upstream and with some ramshackle houses on the right. In one respect, it is quite a traditional rural scene, untouched by industrialization. The composition is simple, allowing the artist to focus on the light effects on the snow in the foreground. Monet was fascinated by extremes of weather, and the winter of 1879–80 was severe, inspiring many paintings of snow scenes.

MC

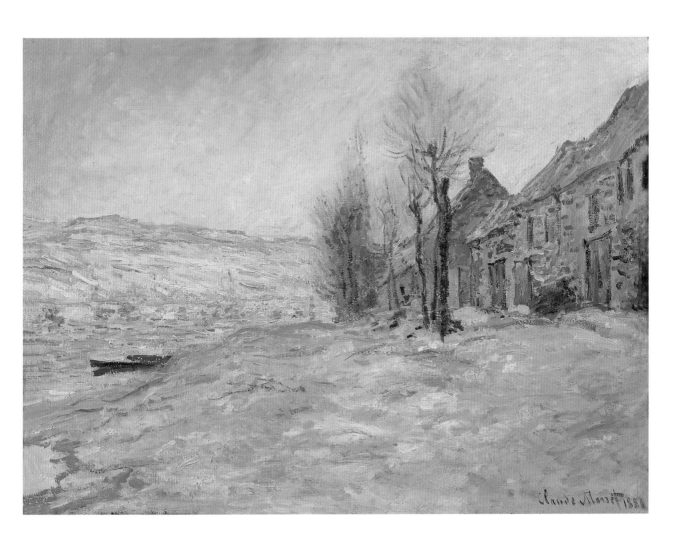

Claude Monet
b. Paris, 1840 – d. Giverny, France, 1926

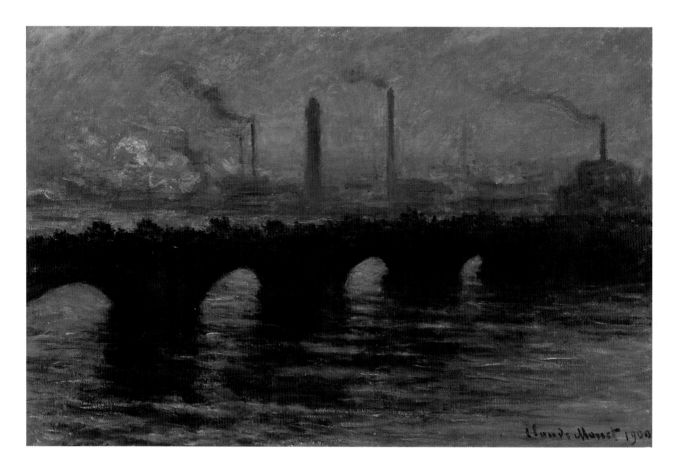

Waterloo Bridge

1900
Oil on canvas
65 × 100 cm
Signed and dated, lower right,
Claude Monet 1900

Durand-Ruel Galleries, Paris;
Hugh Lane; purchased by Mrs
Ella Fry for the Gallery of Modern
Art in Dublin, 1905
Reg. No. 304

As early as December 1880, Claude Monet had thought about creating a group of paintings of the River Thames in London, but he did not start the series until 1899. He spent three periods in London between September 1899 and March 1901. Over the next five years he was to produce ninety-five views of the river in three major subject groups – Waterloo Bridge, Charing Cross Bridge and the Houses of Parliament. He worked at great speed and had a vast number of canvases on the go at one time. Some of these were completed back in his studio at Giverny in France. While in London, he stayed at the Savoy Hotel and from the window in his room he could see Waterloo Bridge to his left and Charing Cross Bridge to his right.

Monet painted forty-one pictures of Waterloo Bridge, which links London's West End to the South Bank, then a much more industrial area. In this painting, one of the most famous of the series, the early morning traffic, both vehicular and pedestrian, is indicated by light touches of vibrant reds and pinks. The vertical smoking chimneys in the distance counterbalance the horizontality of the bridge. Monet's intention was to capture the essence of London, with its extraordinary light effects and atmosphere created by the combination of mist and smoke, both industrial and domestic.

MC

Jour d'Été (Summer's Day)

c. 1879
Oil on canvas
45.7 × 75.2 cm
Signed lower right, *Berthe Morisot*

Sir Hugh Lane Bequest, 1917; on loan from The National Gallery, London, since 1979
Reg. No. NG 3264

This is probably the painting that Berthe Morisot exhibited under the title *The Lake in the Bois de Boulogne* in the fifth Impressionist exhibition, held in 1880. Her entries included a number of superb paintings that emphasized the human figure. This work features two fashionably dressed young women, who appear in other works by Morisot, in a boat floating on a lake. The composition is informal. One of the women is seen in profile and appears to be observing three ducks nearby, while the other woman looks directly out at the viewer. On the far shore, there is a tiny detail of a horse-drawn carriage moving swiftly along.

This freely painted work with its rapidly applied brushstrokes is typical of Morisot.

Her technique, based on touches of paint applied in every direction, gives her works a transparent, iridescent quality evident in the shimmering water. This painting is quintessentially impressionist in its attempt to capture the play of light in a scene. Morisot remained faithful to the Impressionist movement throughout her career, participating in the first Impressionist exhibition in 1874 and in most of the subsequent shows. Morisot studied for a time with Jean-Baptiste-Camille Corot (see p. 17), and was married to Edouard Manet's brother Eugène.

MC

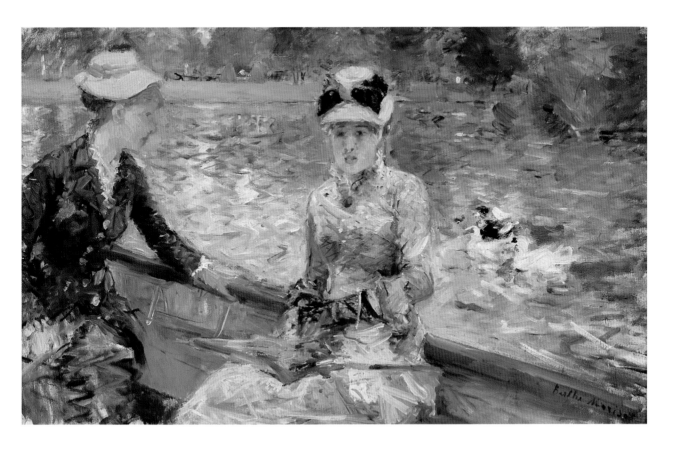

Pierre-Auguste Renoir

b. Limoges, France, 1841 – d. Cagnes, France, 1919

Les Parapluies
(The Umbrellas)

1881–86
Oil on canvas
180.3 × 114.9 cm
Signed lower right, *Renoir*

Sir Hugh Lane Bequest, 1917; on
loan from The National Gallery,
London, since 1979
Reg. No. NG 3268

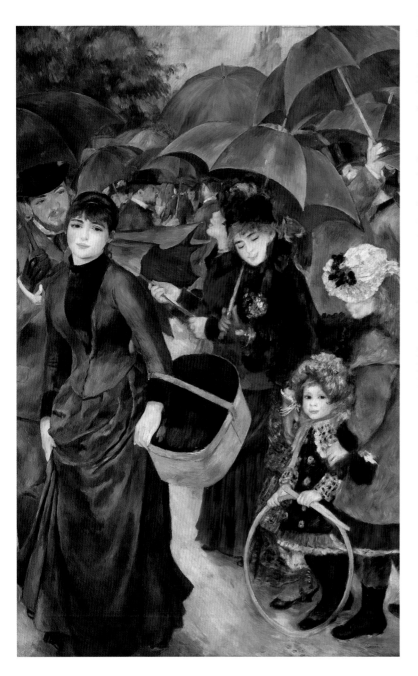

There are two distinct styles evident in this work. In the centre of the painting, a woman wearing a toque and blue cape looks down on a little girl holding a hoop. A red-haired girl to the right lays a protective hand on the young child. These three figures are painted in a fluid, atmospheric manner and recall Renoir's impressionistic style of the 1870s. The woman on the left originally wore clothes close in style to the group on the right, with a frilled skirt, white lace cuffs and a collar. She was also wearing a hat and a belt. The artist reworked this figure in a more severe style, which he called his '*manière aigre*' (harsh or sour manner). This reworking would appear to date from 1885–86.

By 1881 Renoir felt that he had gone as far as he could with Impressionism, and a visit to Italy in 1881–82 inspired a greater sense of structure and solidity in his work. The linear pattern of the umbrella handles, the child's hoop and the handle of the bandbox reflect this new attention to design and form as well as his dissatisfaction with Impressionism. The treatment of the tree in the background would suggest that it was painted after Renoir stayed with Cézanne at L'Estaque in 1882. The Parisian art dealer Paul Durand-Ruel bought this picture from Renoir in 1892 and sold it to Hugh Lane. The painting was one of Hugh Lane's favourites.

MC

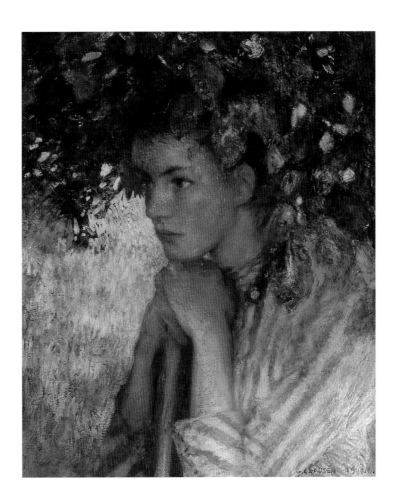

*The Haymaker: A Study
in Shadows*

1904
Oil on canvas
61 × 48.2 cm
Signed and dated, lower right,
G. Clausen, 1904

Presented by the artist, 1904
Reg. No. 267

The son of a Danish interior decorator and a mother of Scottish descent, George Clausen initially studied at the South Kensington School of Design and for a short period of time attended the Académie Julian in Paris. He admired the French artist Jules Bastien-Lepage, a master of *plein air* painting who exerted a strong influence on many Irish and English artists. Clausen painted several scenes of farm workers and explored the theme of light and shade, in internal and external settings, on a number of occasions.

Here Clausen creates a strong sense of intimacy by placing the young farm worker very close to the picture plane. Crowned by rich foliage painted in thick impasto, she seems to be taking shelter from a hot sun portrayed by a vivid and loosely painted yellow background. There are no other indications of her world beyond this, and her

reverie adds to the painting's atmosphere of tranquility and repose. The rendering of the fine facial features of the sitter reveals Clausen's skilled draughtsmanship, and his painterly skills are indicated in the depiction of her ruddy cheeks.

A founder member of the New English Art Club and Professor of Painting at the Royal Academy of Arts, London, Clausen was also appointed an official war artist in 1917.

JO'D

Frank O'Meara

b. Carlow, 1853 – d. Carlow, 1888

Towards Night and Winter

1885
Oil on canvas
150 × 125 cm
Signed and dated, lower left,
Frank O'Meara 1885

Lane Gift, 1912
Reg. No. 26

Towards Night and Winter is a fine example of *plein air* painting as practised by Frank O'Meara at the artists' colony of Gréz, a picturesque village on the banks of the river Loing near Fontainebleau. After a period of study at the atelier of Carolus-Duran in Paris, O'Meara worked at Gréz from the mid-1870s onwards. In this painting, a graceful young girl in a plain grey dress is engrossed in the activity of burning leaves beside the river. A sense of stillness and calm infuses the work: the solid forms of the houses in the background are reflected in the almost static river. The paint is carefully applied and the colours are muted in tone, with the foreground of grass and leaves rendered in a more impressionistic style.

In his compositions O'Meara tended to favour single figures and this contributes to the melancholic atmosphere of his paintings. Indeed, there is a wistful, lyrical quality about much of O'Meara's work and many of his themes are on autumn or winter subjects. In this regard, he was influenced by John Everett Millais and in particular by his painting *Autumn Leaves* (1855–56; Manchester City Art Galleries), which shows three girls making a bonfire of leaves. The Symbolist works of Puvis de Chavannes (see p. 19) were also influential.

The Hugh Lane has five paintings by the artist in its collection, which together form the nucleus of O'Meara's small œuvre.

MC

b. Florence, Italy, 1856 – d. London, 1925

Portrait of Sir Hugh Lane

1906
Oil on canvas
74.3 × 62.2 cm
Signed upper left, *John S. Sargent*

Lane Bequest, 1913
Reg. No. 132

John Singer Sargent was one of the most fashionable portrait painters of his day. In 1874 he studied in Paris with the French portrait painter Carolus-Duran. Sargent greatly admired the work of Diego Velázquez and Frans Hals, and in 1879 he travelled to Madrid and Haarlem to study the works of these masters. The furore surrounding Sargent's portrait of the society beauty Madame Gautreau, or Madame X (1883–84; Metropolitan Museum of Art, New York), when exhibited at the Paris Salon of 1884 resulted in his moving to London. The subsequent enormity of his popularity in England and the US as a society portrait painter led Sargent, who had tired of the genre, to abandon portraiture after 1910.

Hugh Lane was an admirer of Sargent and this work was commissioned by Lane's supporters and presented to him at a ceremony in Dublin on 11 January 1907 in recognition of his "strenuous labour for the public good, tireless energy, and splendid generosity; combined with brilliant organizing capabilities and fine judgement". Sargent depicts Lane the art dealer, collector and founder of one of the first galleries of modern art as a languid and elegant figure, and the portrait had pride of place in Lane's own home in London, Lindsey House, 100 Cheyne Walk, Chelsea.

JO'D

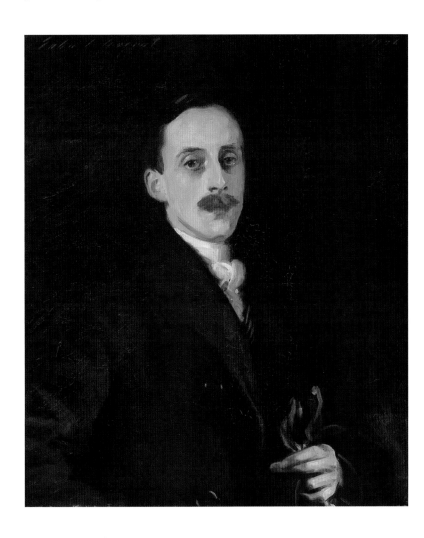

John Lavery

b. Belfast, 1856 – d. Kilkenny, 1941

Mrs Lavery sketching

1910
Oil on canvas
202.8 × 99.1 cm
Signed lower right, *J. Lavery*

Presented by Sir Hugh Lane, 1910
Reg. No. 37

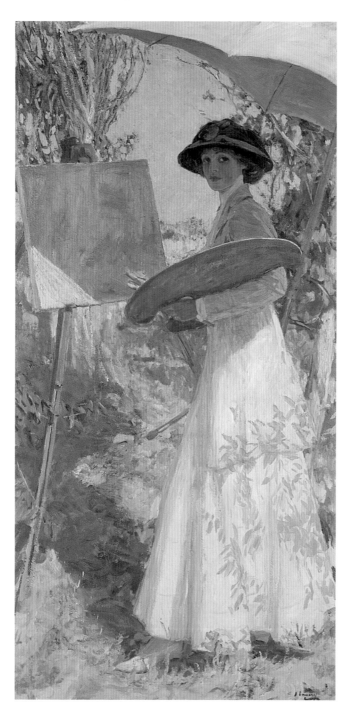

This full-length portrait depicts John Lavery's second wife, Hazel Martyn, who was thirty years his junior. It was painted the year after their marriage in 1909. They had first met in France in 1904 at the artists' colony of Beg-Meil in Brittany, where Lavery was based at that time. Hazel was an aspiring artist who had travelled to France to be among artists. Her beauty captivated Lavery and she became his muse and model until her death in 1935. His best-known portrait of her featured on the Irish pound note until the 1970s.

In this work she is seen sketching in oil in *plein air* beneath a large parasol. The composition is reminiscent of Monet's *Study of a Figure Outdoors (Facing Right)*, (1886; Musée d'Orsay, Paris), and also of Sargent's *A Morning Walk*, (1888; Ormond Family). She looks directly at the viewer with an intimate gaze. The influence of French Impressionism is evident in the sketchy manner in which the paint has been applied. It was probably painted out of doors.

Although born in Belfast, John Lavery received his art education in Glasgow, London and Paris. The Laverys settled in London, where the artist became one of the best-known society portraitists of the Edwardian era.

Hazel Lavery is the subject of other works by Lavery in the collection, including *Hazel Lavery (Brown Furs or Dame en Noir)* (1906).

MC

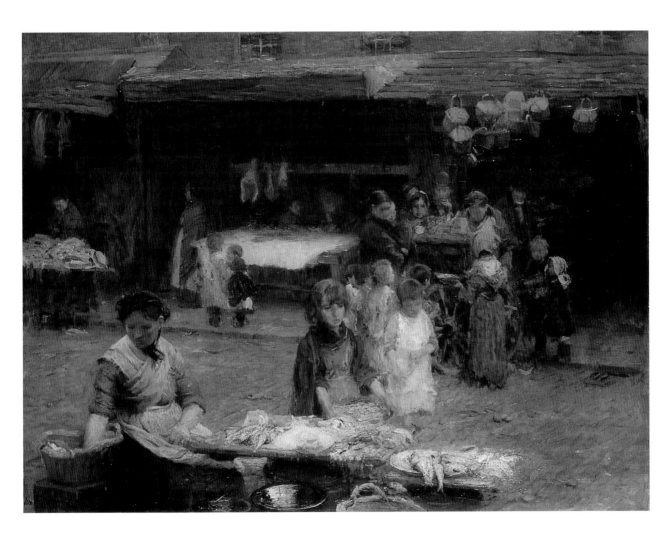

The Fishmarket
1893
Oil on canvas
59.7 × 80 cm
Signed and dated, lower left,
Walter Osborne '93

Lane Gift, 1912
Reg. No. 23

Walter Osborne was a versatile artist who had a successful career as a landscape and genre painter and later as a portraitist. He attended the Royal Hibernian Academy Schools, Dublin, before moving to Antwerp in 1881 to study with the painter Charles Verlat. He then went to Brittany where he absorbed the influence of *plein air* painting. From 1884 he spent prolonged periods in England painting rural scenes, but family circumstances forced him to return to Ireland permanently in 1892 where he established a successful portrait practice.

The Fishmarket, a vivid evocation of life in Dublin at the end of the nineteenth century, is one of his finest genre scenes. Osborne spent much of his time sketching in the market area around Patrick Street.

Although the style of this painting is impressionistic, his eye for detail is evident in the still-life elements on the table in the foreground and the sides of meat hanging in the background. Osborne empathized with working people and the figure of the woman, engrossed in her work, is beautifully rendered. This particular woman appears in many of Osborne's works. He also excelled at painting children without being overtly sentimental.

Hugh Lane bought this painting after Osborne's untimely death from pneumonia at the age of forty-three.

MC

Roderic O'Conor

b. Milltown, County Roscommon, 1860 – d. Neuil-sur-Layon, France, 1940

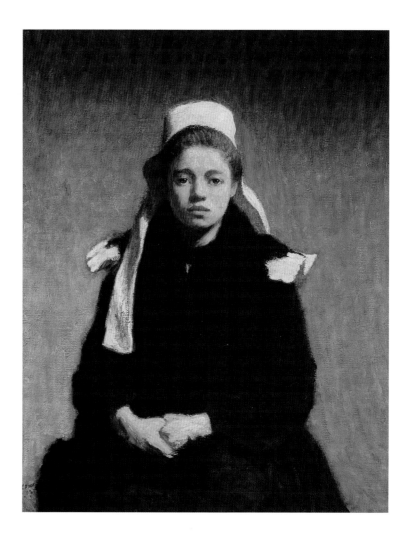

*Une Jeune Bretonne
(A Young Breton Girl)*

1903
Oil on canvas
91.5 × 73.6 cm
Signed and dated, lower left,
O'Conor '03

Presented by the artist, 1904
Reg. No. 224

Roderic O'Conor studied art at the Metropolitan School of Art in Dublin before moving to Paris in 1886. He was based at Pont-Aven in Brittany from 1891 to 1904 and was part of a group that had formed around Gauguin. He was also greatly influenced by the work of Van Gogh, although there is no evidence to suggest that he ever met him.

This young Breton girl is the subject of several portraits by O'Conor from his time in Pont-Aven. The sitter wears traditional Breton dress but the '*ailes*' of her headdress are untied and hanging down, which indicates that she is in mourning. She also wears a heavy black shawl around her shoulders. That she has been bereaved is also evident from the melancholic, resigned expression on her face.

This work sees O'Conor return to a more conservative, academic style of painting and calls to mind the work of Vermeer . The composition is traditional and classical with the figure forming a simple, dignified, symmetrically placed triangle. It contrasts sharply with O'Conor's more expressive Pont-Aven landscapes and seascapes from the previous decade, although passages of the painting recall the 'striping' technique of these works in a more muted form.

Hugh Lane selected this painting for inclusion in the exhibition of Irish art that he organized for the London Guildhall in 1904. It was hung in Gallery One, which contained a selection of the most significant works.

MC

b. Munich, Germany, 1860 – d. Bathampton, Somerset, 1942

The Old Church at Dieppe

c. 1898–1905
Oil on canvas
33 × 41 cm

Lane Gift, 1912
Reg. No. 16

Walter Sickert was of Danish, German and Irish extraction. His family arrived in London from Germany in 1868. At first Sickert took up acting, but soon decided to become a painter. After a short period at the Slade School of Fine Art, he entered the studio of Whistler (see p. 25), from whom he received introductions to many French Impressionists in both Paris and Dieppe. He remained in Dieppe from 1898 to 1904, seeing it as a second home after London. He adored painting the façade of the medieval church of Saint Jacques, showing it from various angles and at different times of the year, fully exploring all aspects of the subject under scrutiny, much in the vein of Monet's studies of Rouen Cathedral in the 1890s. In this painting, the view takes in the rue du Mortier, which is to the rear of the church. Unlike those of many of his contemporaries, Sickert's palette was excessively gloomy. This seems to have been a philosophical stance consciously cultivated by the artist. The subject-matter of his compositions lent itself deliberately to sombre tones, subdued colouring and low lighting, linking his art very much to the literature of Emile Zola, who conjured up naturalistic scenes that were similarly pervaded by an atmosphere of gloom.

PC

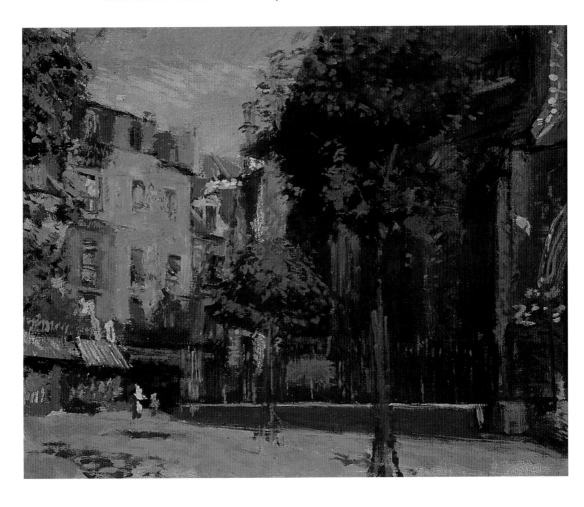

May Guinness
b. Dublin, 1863 – d. Dublin, 1955

Still Life

1925–30
Oil on canvas
142 × 76 cm

Presented by the Estate of the late
Miss May Guinness, 1956
Reg. No. 1065

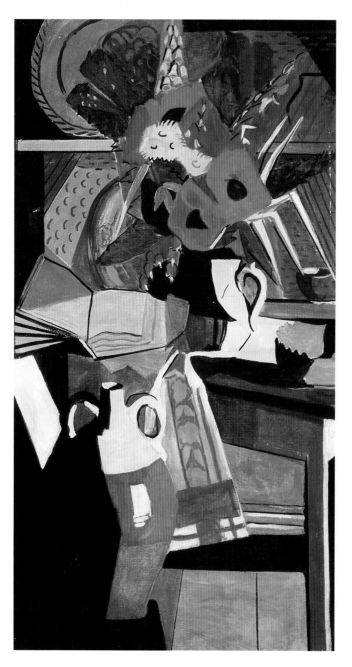

While May Guinness came to painting relatively late in life, she was to study with some of the most well-known artists of early Modernism. She also exhibited and travelled widely during her long lifetime and was a collector of modern art. She attended classes given by Norman Garstin, an exponent of *plein air* painting, at Newlyn, Cornwall, in 1894 and later in 1905 in Brussels. Guinness admired the decorative style and bold use of colour of Matisse and the Fauves, and she received lessons from the Dutch artist Kees van Dongen. From 1922 to 1925 she studied with the Cubist painter and influential art teacher André Lhôte.

In *Still Life* Guinness graphically articulates the solidity of the various objects she is painting by using thick black outlines and by emphasizing strong contrasts of light and shade. The sophisticated compositional arrangement of this work sees a juxtaposition of vertical, horizontal and diagonal lines combined with lively decorative patterns and heightened with areas of pure colour. Not only adventurous and strong-willed in pursuing her artistic interests, Guinness also joined the French army as a military nurse during World War I, and was awarded the Croix de Guerre and the Medáille de la Reconnaissance Française for her bravery.

JO'D

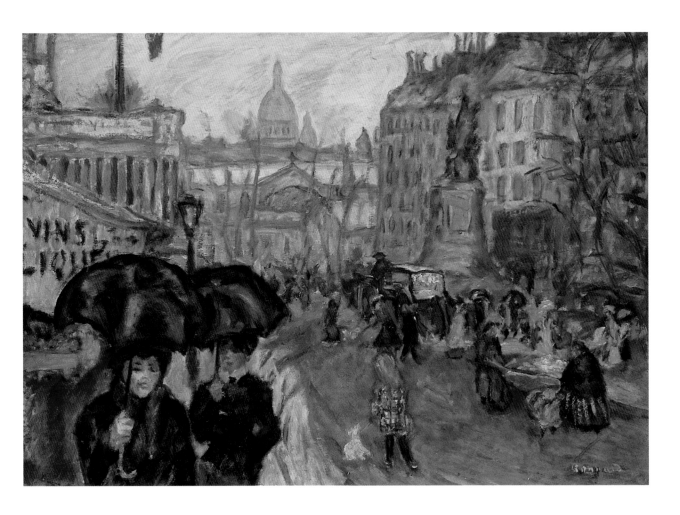

Boulevard de Clichy

c. 1911
Oil on canvas
50 × 69 cm
Signed lower right, *Bonnard*

Presented by the Friends of the
National Collections of Ireland,
1941
Reg. No. 861

From as early as 1889 Pierre Bonnard had
become fascinated by the changing patterns
formed by people passing along the streets
of Paris in the neighbourhood of his
successive studios near place de Clichy,
Montmartre. Here he depicts the boulevard
de Clichy on a rainy day with the dome of
the Sacré Coeur in Montmartre visible in
the background. This modern-life subject
reflects Bonnard's interest in the human
dimension of the city, with more emphasis
placed on the figures than on architectural
verisimilitude.

In its freely brushed surfaces, this
painting reveals Bonnard's return to a
handling closer to Impressionism, in
contrast to his paintings of the 1890s with
their more linear style. Bonnard's skill lay in
representing a precise moment in the day,

almost like a freeze-frame from an early
silent film. Precedents for the composition
of this work can be found in Japanese
woodblock prints, photography and the
work of Degas (see pp. 26–28). An interest
in decorative and applied art is evident in
his treatment of the young girl's coat in the
foreground.

Bonnard began his artistic career as a
graphic artist and designer-decorator. Like
Vuillard (see p. 44), he was a member of the
Symbolist group the Nabis (the Hebrew word
for 'prophet').

MC

Edouard Vuillard

b. Cuiseaux, France, 1868 – d. La Baule, France, 1940

La Cheminée
(The Mantelpiece)

1905
Oil on cardboard
51.4 × 77.5 cm
Signed and dated, lower right,
E. Vuillard, 1905

Sir Hugh Lane Bequest, 1917; on
loan from The National Gallery,
London, since 1979
Reg. No. NG 3271

Edouard Vuillard was one of the main practitioners of intimate domestic genre painting ('Intimism'). This painting, a combination of an interior scene and a still life, was painted in the artist's room at Château-Rouge in Amfreville, Normandy, which was rented for the summers of 1905, 1906 and 1907 by the artist's friends Jos and Lucy Hessel.

An emphasis on surface pattern and decoration is one of the defining characteristics of Vuillard's work. The floral wallpaper in this work vies for attention with the posy of wild flowers, bottles and illustrations on the mantelpiece. Above the mantelpiece, the edge of a mirror framed in bamboo can be observed. Another painting is visible on the back wall and beneath this some white rags that have been hung up to dry on a clothes rack. The marble mantelpiece juts out, creating an almost three-dimensional effect. This, together with the cropped effect, calls to mind a

photographic image. In its freely brushed surfaces, the picture reflects a handling close to Impressionism.

For a time, Vuillard was one of the central figures of the Nabis, a group of Parisian avant-garde artists that included Bonnard (see p. 43) and Félix Vallotton among its members.

MC

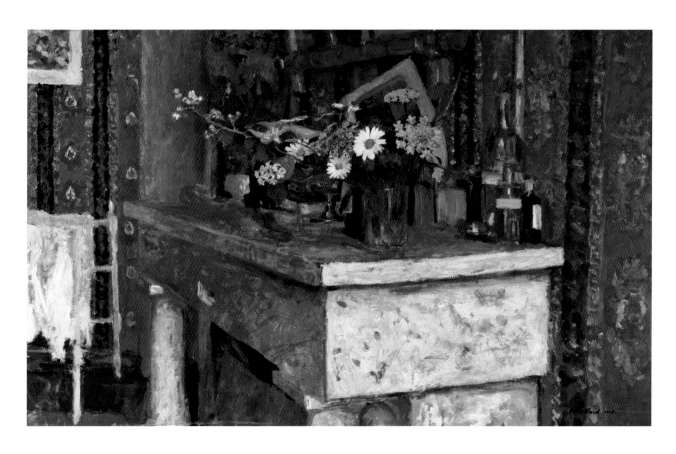

b. Peterhead, Scotland, 1868 – d. Dublin, 1953

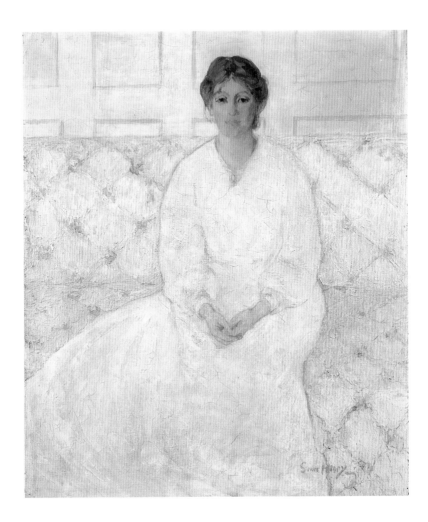

The Girl in White

c. 1910–12

Oil on canvas

61 × 50.8 cm

Signed, lower right, *Grace Henry*

Presented by Mr Justice James Creed Meredith, K.C., 1930

Reg. No. 654

Grace Henry's work was for many years overshadowed by that of her husband, Paul; recently, however, her position has been re-examined. Her œuvre has proved both restless and experimental. This painting is one of the finest examples of her work.

Grace Mitchell studied art in Brussels and Paris, and it was there that she met Paul Henry in 1900. A chance holiday to Achill Island, County Mayo, in 1910 prompted a move to the west of Ireland that heralded much of the most familiar work by these artists. Returning to Dublin in 1920 they co-founded the Society of Dublin Painters, which became synonymous with the avant garde. The couple later separated and Paul Henry omitted any reference to her in his subsequent two volumes of autobiography. During the 1920s and 1930s Grace travelled extensively around Italy and France, studying under the Cubist painter André Lhôte in Paris. In 1949 she was elected an Honorary Member of the Royal Hibernian Academy.

The Girl in White differs from Henry's peasant scenes of Achill through the use of subtle tones and a limited palette, referencing the influence of French and English painters, and in particular of Whistler (see p. 25). It also calls to mind the work of Gwen John (see p. 49). The lone sitter's pose suggests a quiet moment in the expanse of the room. The subtlety of the portrait, with the face and hands barely formed, adds a quality of simplicity and perhaps reveals a contemplative nature; the inward gaze is characteristic of Henry's work.

GJ

Jack B. Yeats

b. London, 1871 – d. Dublin, 1957

The Ball Alley

1927
Oil on canvas
46 × 61 cm
Signed lower right,
Jack B Yeats

Presented by the Friends of the
National Collections of Ireland,
1973
Reg. No. 1337

The son of the painter John Butler Yeats (see p. 29) and brother of the poet W.B. Yeats, Jack B. Yeats lived for most of his childhood in Sligo with his maternal grandparents, William and Elizabeth Pollexfen, by whom he was especially adored. An enormously prolific artist, he produced approximately 1200 paintings and around 700 drawings during the course of his lifetime, becoming the most internationally renowned Irish painter of the first half of the twentieth century. He also wrote short plays, illustrated books and contributed articles and illustrations to various publications, including several to accompany J.M. Synge's 1905 *Manchester Guardian* article on life in the west of Ireland.

Yeats's early work was mostly illustrative and the exuberant vitality of circuses, boxing rings, fairs and music halls, and the characters populating such worlds, provided rich sources of inspiration. His depiction of distinctively Irish characters and rituals led Yeats to receive critical acclaim as a markedly Irish painter. *The Ball Alley,* which was developed from a 1905 sketch, depicts a sport that was once the cornerstone of Irish village life. The work reveals Yeats's uniquely expressive, painterly style and his use of a dramatic compositional arrangement to depict a hiatus in the fast-moving game where the intense interaction between players and spectators contrasts starkly with the bare wall filling up most of the canvas.

JO'D

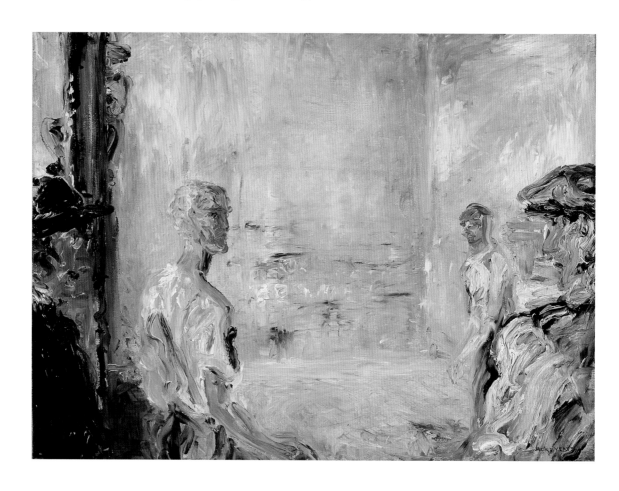

b. London, 1871 – d. Dublin, 1957

There Is No Night

1949
Oil on canvas
102 × 153 cm
Signed and dated, lower right,
Jack B Yeats, 1949

Purchased, 1980
Reg. No. 1312

Jack B. Yeats attended a number of art schools in London, including the South Kensington School of Art and Westminster School of Art. However, his painting style, while wholly modern, remained independent of any Modernist school. As in the case of *There Is No Night*, the title of which is adapted from the Book of Revelation (22:5), Yeats would sometimes use titles from literary sources, which he modified for his own use. While his early work was predominantly illustrative, Yeats later felt little desire to explain his painting. This creative independence was admired by many, including the playwright Samuel Beckett, a friend of the artist.

Boats and the sea captured Yeats's imagination for his entire life, a love that may have been sparked initially by his grandfather's sea-trading business. Yeats was also deeply attached to horses and donkeys, and these subjects often acquired additional symbolic significance in his painting. *There Is No Night* is painted using thick impasto oil paint. With a characteristic balance between expressive brushstrokes and control, areas of pure colour squeezed directly from a paint tube and barely painted areas of canvas, Yeats situates a rising man and galloping white horse in a textured, joyful and revelatory landscape.

JO'D

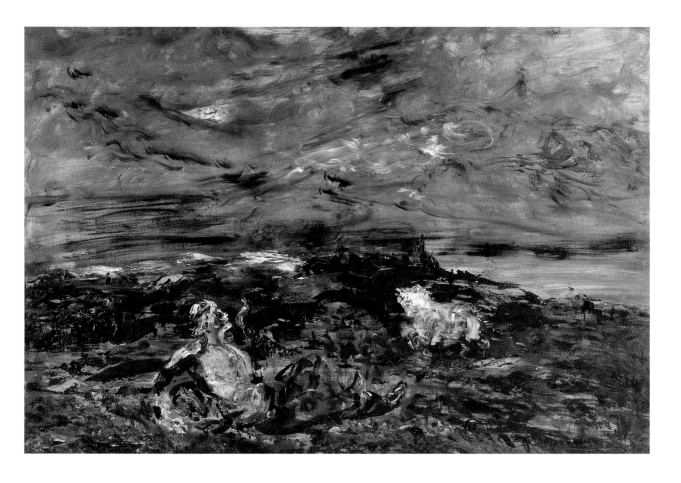

Georges Rouault
b. Paris, 1871 – d. Paris, 1958

Christ and the Soldier

1930
Gouache, crayon and ink on
board
63.5 × 48.2 cm
Signed and dated, lower centre,
G. Rouault 1930

Presented by the Friends of the
National Collections of Ireland,
1956
Reg. No. 1063

One of the great religious artists of the
twentieth century, Georges Rouault revived
biblical subjects and reinterpreted them in a
modern context. The son of a cabinet-maker,
Rouault served a five-year apprenticeship
as a stained-glass artist before deciding to
become a painter and entering the Ecole des
Beaux-Arts in Paris to study under Gustave
Moreau.

The dark contrast and vibrant areas of
colour in *Christ and the Soldier* are instantly
reminiscent of stained-glass windows.
Around 1929 the Passion of Christ became
a dominant theme for Rouault and in this
work he depicts the moment after the crown
of thorns has been placed on Christ's head.
Christ is wearing a red mantle and behind
him a Roman soldier stands with a reed,
ready to strike. A number of figures peer out
of an open window.

When this work was offered to the Gallery
in 1942 it was rejected on the grounds that
its modernity was blasphemous. The artist
Seán Keating (see p. 61) was one of its most
vociferous opponents. Ironically, two months
later, the painting went on loan to an ultra-
conservative religious institution, St Patrick's
Seminary in Maynooth, before eventually
being accepted by the Gallery in 1956.

MC

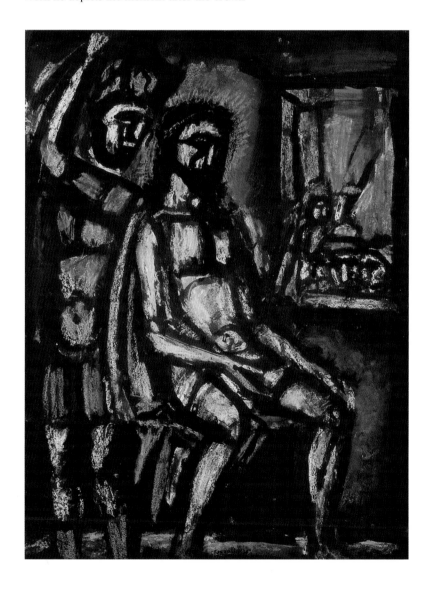

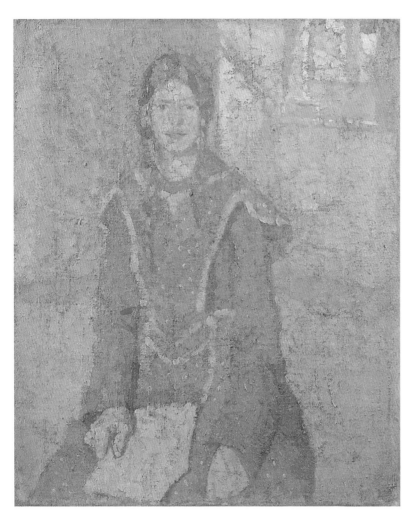

Study of a Young Girl
(recto): *Study of a Young
Girl with a Hat* (verso)

c. 1918–22
Oil on canvas
44.5 × 37 cm

Presented by A.E. Anderson, 1929
Reg. No. 642.01

Gwendolin John studied at the Slade School of Fine Art, London, as did her brother Augustus (see p. 53). Her training at the Slade instilled within her the importance of drawing from life. She went on to study at Whistler's Academy Carmen in Paris, subsequently deciding to move to Paris permanently, in 1903–04, earning her living by posing for other artists. Contemplative yet arresting, Gwen John's figure paintings and self-portraits reflect a lifelong interest in *la vie intérieure*.

The lone sitter in this study of a young girl is characteristic of John's work. The three-quarter-length pose references the monumental, yet the sitter's unkempt appearance and inward gaze contrast with other images of women made at that time. The calm harmony, subtle tones and brushstrokes blend the sitter with the background. Everything existed for John in the half-light of a dusty little corner of her studio.

On the reverse of the canvas, upside down, is an unfinished portrait of a girl with a hat, a study for a work now in a private collection. Although John visited England occasionally, her work was seldom seen until a memorial exhibition at the Matthiesen Gallery, London, in 1946 established her reputation.

GJ

Maurice de Vlaminck
b. Paris, 1876 – d. La Tourillière, France, 1958

Opium

c. 1908–10
Oil on canvas
81.6 × 53.7 cm
Signed lower right, *Vlaminck*,
upper left, *Opium*

Presented by the Friends of the
National Collections of Ireland in
memory of Sarah Purser, 1944
Reg. No. 922

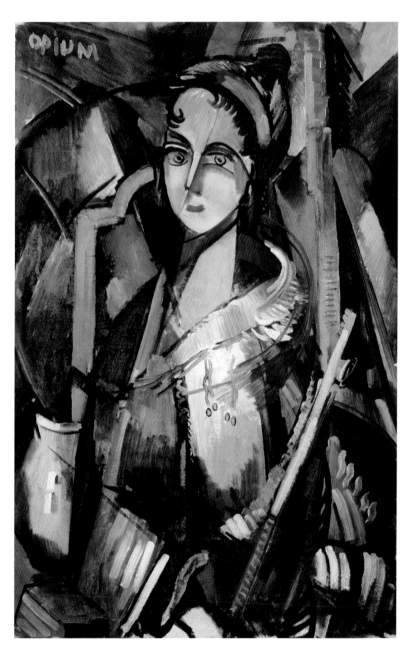

Maurice de Vlaminck was a self-taught painter who, along with André Derain and Henri Matisse, was part of the Fauve group, a seminal movement in French painting at the beginning of the twentieth century. From 1908 to 1914 Vlaminck experimented with Cubism, and *Opium* is one of the finest examples of his work from this period. The choice of subject, a seated woman holding an opium pipe, is an unusual one but it is also an exceptional work in that Vlaminck usually applied his Cubist style to his still-life studies. Like Derain, Vlaminck was attracted to primitive tribal art and the influence of African masks is much in evidence here, in particular in the face. He claimed to have first encountered African statuettes as early as 1904, and certainly by 1905–06 he and Derain had bought some masks. From 1907 to 1910 the influence of the work of Cézanne was also crucial, with Vlaminck particularly admiring its structural elements. This influence can be observed in *Opium*, with its fragmented planes. Compared with the brightly coloured works from his Fauve period the greenish-blue tonality of this work seems muted, although he makes distinctive use of thick white hatching to highlight parts of the painting.

MC

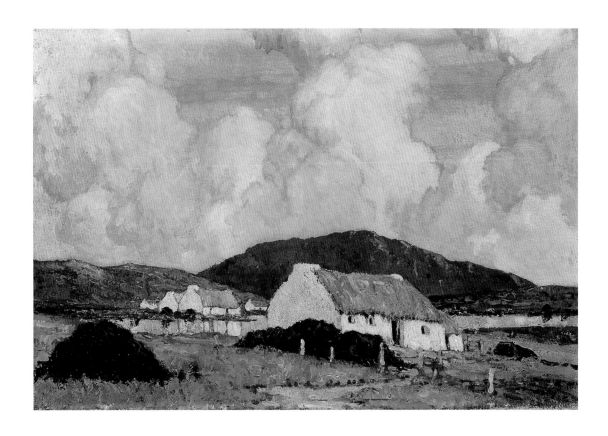

Lakeside Cottages

c. 1929
Oil on canvas
41 × 61 cm

Presented by the Thomas Haverty
Trust, 1935
Reg. No. 763

With the financial support of a relative, Paul Henry travelled to Paris in his early twenties, where he studied at the Académie Julian. He also briefly attended the Académie Carmen, the school run by the American artist Whistler (see p. 25), a master of delicate tonal harmonies. As an aspiring artist, Henry admired the work of Jean François Millet and Van Gogh, both of whom were sympathetic painters of peasant life.

Henry's twelve years working as an illustrator in London are reflected in the graphic solidity and clarity of his painted work. In 1912 he moved to Achill, County Mayo, with his wife, the artist Grace Henry (see p. 45), where he remained for seven years, painting the everyday lives of local people at their work. Set amid the dramatic landscape and billowing, cloud-filled skies characteristic of the Atlantic seaboard, *Lakeside Cottages* dates from a time when Henry's work had reached its maturity.

Thematically, it is one of many works featuring cottages by a lake, and the deceptive simplicity of its composition, with its subtle repetition of geometric forms, belies the accomplished skill with which it was painted.

JO'D

William Orpen

b. Stillorgan, County Dublin, 1878 – d. London, 1931

Reflections: China and Japan

1902
Oil on canvas
40.5 × 51 cm

Lane Gift, 1912
Reg. No. 35

William Orpen entered the Dublin Metropolitan School shortly before his thirteenth birthday. An extremely talented pupil who excelled in drawing, he was highly esteemed as a student who was eager to learn. In 1896 he attended the Slade School of Fine Art, and he lived and worked in London for the remainder of his life, pursuing a highly successful and lucrative career as a portraitist. However, Orpen maintained links with Ireland through his influential role as a part-time teacher at the Metropolitan School of Art, by contributing work to exhibitions, and by spending summer holidays with his family at Howth, County Dublin. He also painted a number of allegorical works inspired by Irish subject-matter. Orpen was a close friend of Hugh Lane, to whom he was also distantly related, and Lane's astute acquisition of modern French masters is celebrated in Orpen's painting *Homage to Manet* (1909; Manchester City Art Gallery). While Orpen had accompanied Lane to Paris to acquire these works in 1905, his own painting eschewed contemporary avant-garde developments. *Reflections: China and Japan* is a virtuoso still-life painting that demonstrates Orpen's facility at depicting texture and reflective surfaces with flair and skill, and with less emphasis placed on a coherent compositional arrangement.

JO'D

Decorative Group

1908
Oil on canvas
202 × 173.4

Lane Bequest, 1913
Reg. No. 120

One of the leading portraitists of his time, Augustus John studied under Henry Tonks and Philip Wilson Steer at the Slade School of Fine Art, London, where he was one of the most promising students. Fellow students included William Orpen (see p. 52), with whom he travelled to Paris in 1899 to see the work of the Old Masters.

Decorative Group is a portrait of the artist's first and second wives and four of his children. The young woman holding a baby in her arms is Ida Nettleship, who died in 1907, five days after giving birth to their fifth child, Henry. The monumental female figure seen in profile and taking a flower from the young boy is John's second wife, Dorelia, with whom he had two children. Her dominant position in the composition reflects the importance of her role in John's life, and she remained his inspiration for nearly sixty years. Around the time of this work, John started using his children as models. On holiday in France in September 1908, he wrote to a friend that his children looked like "healthy vagabonds".

Like many of John's works, this painting can be interpreted as a commentary on birth, life and death. The image of a family placed in a fantastic landscape calls to mind the work of Puvis de Chavannes (see p. 19), whom John admired. Augustus John's sister, Gwen, was also a noted painter (see p. 49).

MC

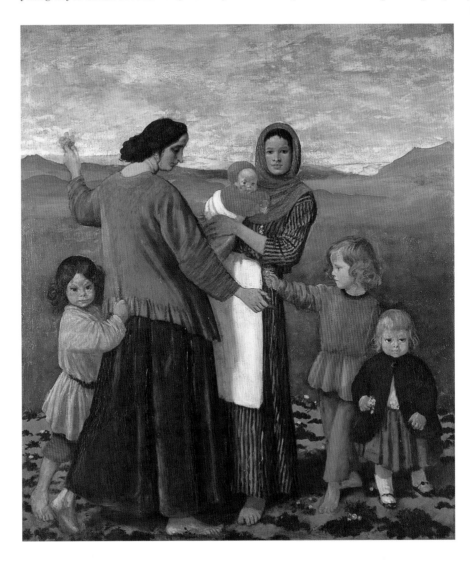

Paul Klee

b. Münchenbuchsee, Switzerland, 1879 – d. Muralto-Locarno, Switzerland, 1940

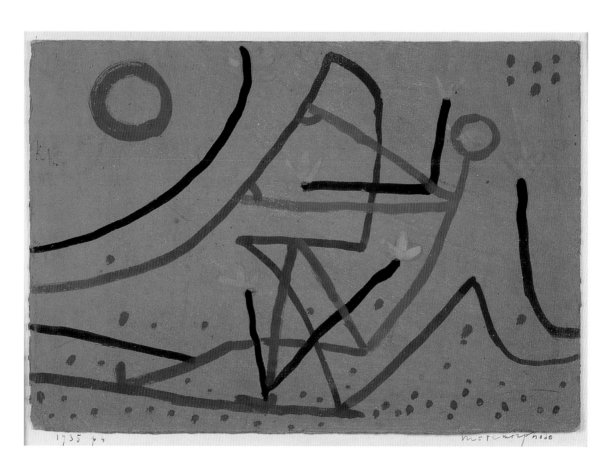

Metamorphose

1935
Gouache on cardboard
22.5 × 32 cm
Signed upper left, *Klee*

Bequest of Mr C. Bewley, 1969
Reg. No. 1300

A gifted artist, musician and teacher, Paul Klee produced nearly 10,000 works on paper during his lifetime. Cubism and metaphysics were among his artistic influences, and he also admired primitive art and the art of children, which he believed exemplified an unselfconscious directness of expression. His exposure to North African light during a visit to Tunisia in 1914 was a revelation to him and heightened his lifelong appreciation of colour. From 1921 to 1931 Klee taught at the Bauhaus and *The Thinking Eye* and *The Nature of Nature* are among his published writings from this time. *Metamorphose* is characteristic of Klee's hieroglyphic-like reductivism in its emphatic two-dimensional composition and in its bold simplicity of line. The work depicts a reclining figure in a landscape setting in the process of transforming into a tree. The patterns created by intersecting lines of varying colours vividly suggest movement. Klee believed that "reality is a never ending metamorphosis" and thematically this work reflects Klee's own life at this time, which was in a state of flux. In 1933 he was dismissed from the Düsseldorf Academy by the Nazis, who branded his art as degenerate, and his forced departure from Germany for Switzerland was compounded by deteriorating health.

JO'D

Jacob Epstein
b. New York, 1880 – d. London, 1959

Lady Gregory
1910
Bronze
36 × 35 × 28 cm
Lane Gift, 1912
Reg. No. 98

Born in New York to Russian–Polish parents, Jacob Epstein initially studied drawing and gained an insight into casting processes while working at a bronze foundry. In 1902 he was invited to illustrate a book about life on the Lower East Side of New York, and the proceeds from this commission enabled him to travel to Paris in the same year, where he attended the Ecole des Beaux-Arts and the Académie Julian. Such a traditional artistic grounding belies the notoriety that would attend the majority of Epstein's public commissions throughout his lifetime. Visits to the Louvre in Paris exposed Epstein to primitive and antique sculpture, and both expressive and naturalistic styles were to be hallmarks of his work. In 1905 he settled in London and became a successful portrait sculptor, making busts of many leading figures of the day. Augusta, Lady Gregory (1852–1932) was a central figure in the Celtic Revival in Ireland and co-founder of the Abbey Theatre. She herself penned several plays drawn from Irish themes. Hugh Lane, Lady Gregory's nephew, commissioned Epstein to make this striking portrait bust, and while Lady Gregory's strength of character is captured, neither she nor Lane was entirely pleased with what they regarded as an excessively forthright result. However, Lady Gregory subsequently came to appreciate what she considered to be the work's energy.

JO'D

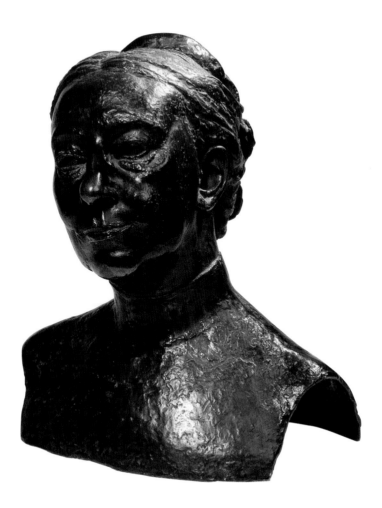

William Leech

b. Dublin, 1881 – d. Guildford, Surrey, 1968

Un Matin (Waving Things, Concarneau)

1918–20
Oil on canvas
112.4 × 127.4 cm
Signed lower left, *Leech*

Presented by the artist in remembrance of Hugh Lane
Reg. No. 228

William Leech was a student of Walter Osborne (see p. 39) at the Royal Hibernian Academy Schools, Dublin, before moving to Paris in 1901. He then spent more than five years at Concarneau in Brittany, and although he eventually settled in England he made several return visits to France over the years. Leech enjoyed painting flowers and plants and produced a number of studies of aloes, of which this is a fine example. It is likely that it was painted at Grasse near Les Martiques in France.

Leech excelled as a colourist. In this work his palette is restricted mainly to greens and blues, but he used dashes of purple, orange and zinc white to enliven it (he was later dissatisfied with his use of zinc white, however). The forms of the plants dominate the composition and give the painting an abstract feel. There is also a strong decorative element that calls to mind the patterned forms of Art Nouveau.

Post-Impressionism had a lasting impact on the artist and the influence of Seurat, Gauguin and Cézanne can be identified. The signature on this work is in the Oriental form Leech used briefly from 1919 to 1920. The carved hand-decorated frame was probably made by Leech, and has been signed on the lower left.

MC

b. Dublin, 1882 – d. Blackheath, London, 1978

Honolulu Garden

c. 1923–24
Oil on canvas
64 × 76 cm
Signed, lower left, *Swanzy*

Purchased, 1976
Reg. No. 1491

Mary Swanzy commenced her artistic career in May Manning's studio, Dublin, where she received occasional tuition from John Butler Yeats (see p. 29). It was Yeats who enticed Swanzy to travel to Paris, and arriving there in 1905 she quickly became engrossed in all the emerging modern French art movements, in particular Cubism. At Gertrude Stein's soirées she had the opportunity to see the art not only of Cézanne and Picasso, but also of many other modern masters, and her work betrays the influence of these artists. On the death of her parents, she gained financial independence and decided to travel. After visiting Eastern Europe, she journeyed to Samoa and on to Honolulu in the early 1920s, recording all she saw in paint, both the countryside and the urban settings.

Honolulu Garden resulted from a trip Swanzy made to Hawaii in 1923, and in a somewhat atypical manner for her she painted the piece without reference to Cubist ideals. She concentrates here on depicting the resplendent light and sumptuous green leaves of exotic plants. The piece is like a tapestry, displaying through colour the warmth of Hawaii. The bending foliage creates a gentle rhythm in the painting, as if the plants are dancing in a breeze.

In 1968 a retrospective exhibition of Swanzy's work was held at Dublin City Gallery The Hugh Lane.

PC

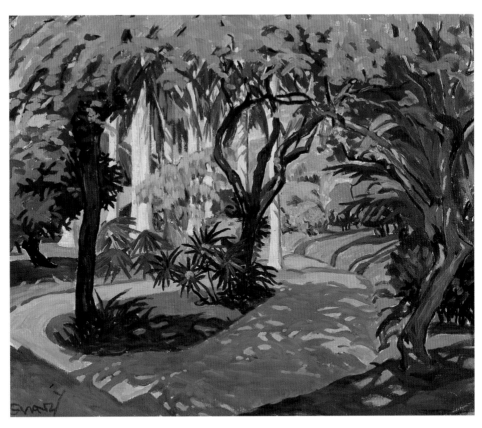

Josef Albers
b. Bottrop, Germany, 1888 – d. New Haven, Connecticut, 1976

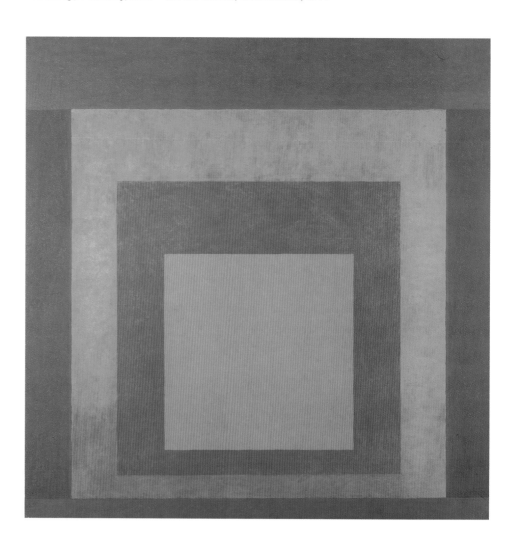

*Homage to the Square –
Aglow*

1963
Oil on board
101 × 101 cm
Monogrammed and dated lower
right, *A63*
Presented by the Friends of the
National Collections of Ireland,
1970
Reg. No. 1292

From 1920 until its forced closure by the
Nazis in 1933 Josef Albers studied and then
taught at the Bauhaus school in Germany.
Like many artists at this time, Albers left
Germany for the US, where he became an
influential art theorist and teacher. He
taught at the avant-garde Black Mountain
College in North Carolina and was
appointed principal of the Yale School of
Design in 1950. It was around this time that
he began his monumental *Homage to the
Square* series. Through this series, which
was eventually to encompass more than one
thousand works in various media, including
works on paper and tapestry, Albers
explored the effects of colour relativism and
interdependency, harmony, proportion and

the perception of colour planes advancing or
receding into depth. He would sometimes
make colour sketches, which would then
be worked up to a larger scale. In 1963,
the year in which this work was painted,
Albers's book *Interaction of Colour* was
published. While the structural formalism of
the *Homage to the Square* series is rigorous,
the titles are occasionally annotated with
additional descriptions, in this case the word
'Aglow', which emphasize the intense
lyricism and the primacy of the visual
experiences that pervade these works.

JO'D

b. Dublin, 1889 – d. Coire, Switzerland, 1931

The Eve of St Agnes

1924
Stained glass
157.5 × 105 cm
Signed and dated, lower right,
Harry Clarke, April 1st 1924

Purchased from Mrs Alison King,
1978
Reg. No. 1442

Harry Clarke's achievements in stained glass can be credited with reviving a medium that had suffered serious decline in Ireland. In 1923, Harold Jacob commissioned a window, "out of the usual run of domestic stained glass", depicting Keats's poem 'The Eve of St Agnes'. Clarke responded with a work of consummate skill, encompassing every technique known to the stained glass artist. Fourteen key scenes conveying the drama and magic of the story are illustrated, topped by two decorative lunettes, with a unifying frieze below showing the dramatis personæ.

Porphyro, forbidden to pursue the hand of Madeline by her father, creeps into the castle during the St Agnes's Eve carousing and is led by Old Angela to Madeline's bedchamber. Madeline, following ancient custom, has retired there fasting to dream of her future lord. Her dreams are fulfilled when Porphyro wakes her, and the two steal away into the gathering storm, past the fluttering tapestry and the drunken porter.

Clarke cleverly disguises the leading in the architectural and decorative features around the scenes by including it as a compositional feature in the design. The dazzling colour is achieved using double-layered glass, repeatedly acid-etched to produce diverse tones, with minute detail scratched into the paint layers using a needle. The window is the result of painstaking work of the utmost complexity and is an extraordinary achievement.

JS

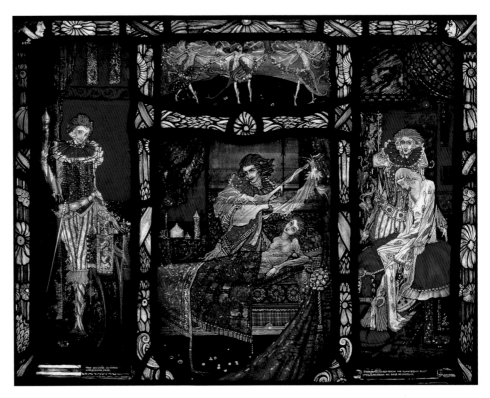

Willi Baumeister

b. Stuttgart, Germany, 1889 – d. Stuttgart, Germany, 1955

Figurazione

1945
Oil on paper mounted on board
28 × 39.5 cm
Signed and dated, lower right,
Baumeister 45

Bequeathed by Mr C. Bewley,
1969
Reg. No. 1299

Willi Baumeister was an important figure in the development of the abstract school in German painting in the first half of the twentieth century. In his formative years he was influenced by Cézanne and Post-Impressionism, before moving on to abstraction in the 1930s.

Figurazione was painted at the end of World War II, when Baumeister was living at Lake Constance. Despite shortages of materials and other problems, he managed to produce a substantial body of work during the War. The major works of these years were the *African* pictures, the *Gilgamesh* series, the *Relief* pictures and the

Perforations. This painting, with its violently gesturing dark hieroglyph-figures, is close in content and style to the *African* paintings, begun in 1942, in which he created a range of symbols that matched his idea of 'African'.

Baumeister was concerned with the philosophy of art and believed that freely imagined forms provide images relating to the deeper, primitive roots of humanity. He repeatedly stated that what he painted came as a surprise and that inner forces urged him on in a direction he had not foreseen. He explained his process in his book *Das Unbekannte in der Kunst* (The Unknown in Art) (1947).

MC

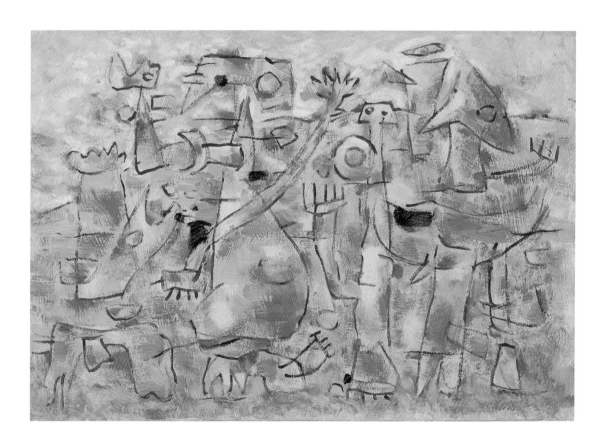

Men of the West

1915
Oil on canvas
97 × 125 cm
Signed lower right, *Keating*

Presented by the artist in memory
of Hugh Lane
Reg. No. 226

Seán Keating attended the Metropolitan
School of Art in Dublin, and was taught by
William Orpen (see p. 52), sharing with
him an interest in visual explorations of
Irish culture. Keating first visited the Aran
Islands in 1913–14, and by the time the Irish
Free State emerged in 1922, he had begun
to develop an imagery of the new Ireland,
combining the country's traditional culture
with a celebration of the industrial
development that was beginning to take hold.

Men of the West shows Keating's
nationalism at its most visionary. Dressed in
traditional costume and armed with rifles,
the three men are seen close up, standing
out starkly from their background. Keating
himself modelled for the figure on the left,
and his brother and a friend for the others;
yet the figures are idealized. Keating depicts
them with unflinching gazes beside the

Republican Tricolour flag, emphasizing their
staunch commitment to the cause. There is
no extraneous detail, and the composition
hinges on the simple combination of figures,
shown in profile and three-quarter views,
endowing the painting with great force.
Exhibited in 1915, the painting acquired
additional emotional and political charge
with the occurrence of the Easter Rising
a year later and the ensuing political
upheaval, which resulted in the
establishment of the Republic of Ireland.

JS

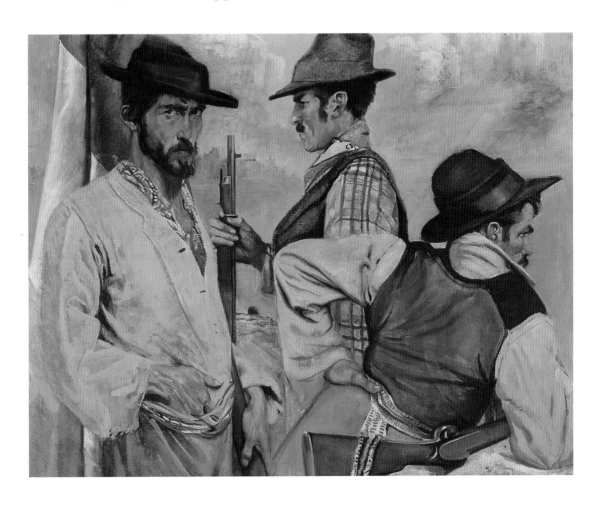

Ivon Hitchens

b. London, 1893 – d. London, 1979

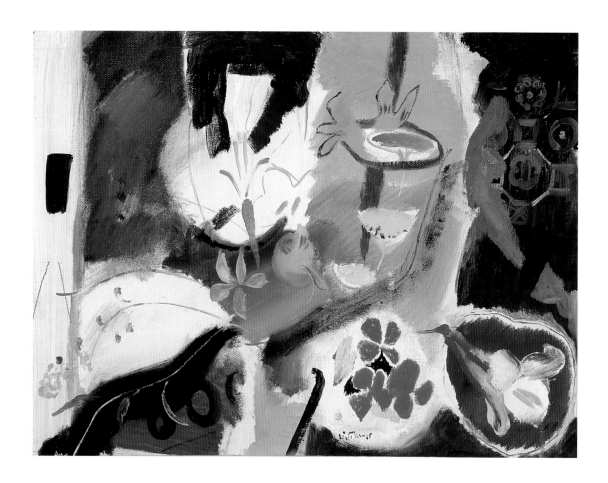

Ringed Lily

1948
Oil on canvas
58.4 × 76.2 cm
Signed lower centre, *Hitchens*

Presented by the Friends of the
National Collections of Ireland,
1968
Reg. No. 1280

Ivon Hitchens attended St John's Wood
School of Art and the Royal Academy of Arts
Schools, London, between 1912 and 1919. A
member of the Seven and Five Group during
the 1930s and influenced by such artists as
Cézanne and Matisse, he exhibited alongside
Ben Nicholson, Barbara Hepworth, Henry
Moore and others, and developed a personal
style of abstract figuration, largely through
landscape painting. Following the bombing
of his London studio in 1940 he moved to
the Sussex woodlands, where he lived for
the remainder of his life and where his
mature style found its full expression.

Ringed Lily exemplifies Hitchens's
interest in evoking the essence of a place,
the effects of light taking precedence over
direct representation. Broad sweeps of
vivid colour are used both structurally and
expressively, and the viewer's eye is led
circuitously over the surface of the painting
by the looseness of the brushwork, only then
being drawn deeper into the composition.
Discussing this sense of rhythmic movement
in his paintings, Hitchens commented, "I use
a notation of tones and colours so that the
design flows from side to side, up and down,
and in and out. I am not interested in
representing the facts as such until this
visual music has been created."

JS

Patrick Joseph Tuohy

b. Dublin, 1894 – d. New York, 1930

*Thady, the Mayo
Country Boy*

1912
Oil on canvas
91.5 × 53.4 cm
Signed and dated, lower right,
Tuohy 1912

Presented by Joseph Holloway,
1934
Reg. No. 726

During the 1920s Patrick Tuohy was one of the most important portrait painters working in the new Irish Free State. He grew up in an environment steeped in Irish Nationalism and it was Patrick Pearse's brother William, a sculptor, who encouraged Tuohy to pursue art. However, he developed a greater interest in European art than in the national equivalent. Tuohy studied at the Dublin Metropolitan School of Art under William Orpen (see p. 52), who emphasized life drawing. In 1916 he visited Madrid and studied the collection at the Prado, in particular the work of Velázquez and Zurbarán.

Thady, the Mayo Country Boy was the first painting exhibited by Tuohy. In 1911 he wrote a letter to his fellow art student James Sleator, stating that he had sketched "a portrait of a little boy in a red petticoat ...". The subject is painted with realism, especially the worn look of the boy's clothing. Tuohy's skill lay in his ability to capture the momentary expression of his subject and the careful balance of light and shade. The boy's face is highlighted, with a glint in his eyes, thus creating a powerful sense of intensity. Tuohy places the boy against a wall, limiting the space and thus making the portrait more intimate.

PC

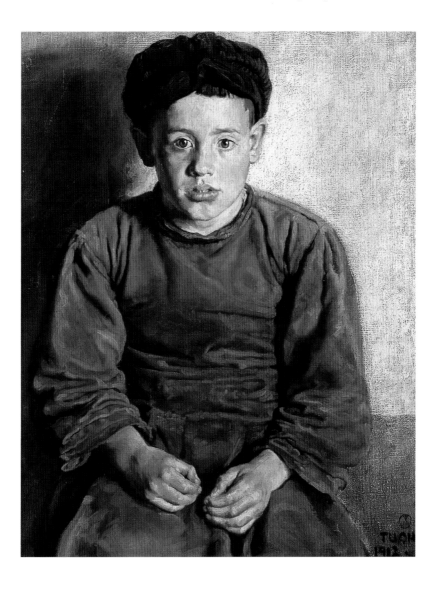

Evie Hone
b. Dublin, 1894 – d. Dublin, 1955

Deposition

c. 1953
Stained-glass panel
36 × 23 cm

Bequest of Mrs Julian M. Egan,
through the Friends of the
National Collections of Ireland,
1961
Reg. No. 1097

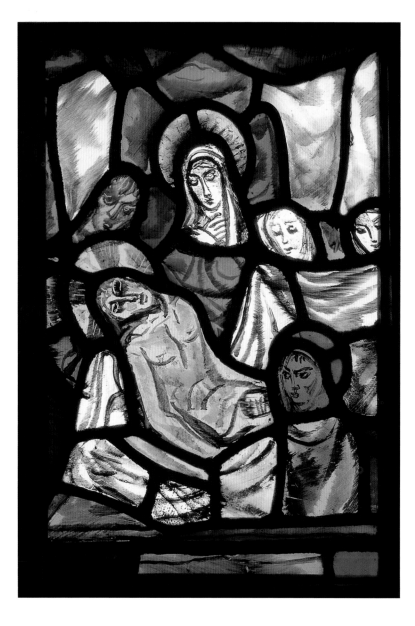

Evie Hone began her career as a painter and studied first with Walter Sickert (see p. 41) in London before going to Paris, where she and Mainie Jellett (see p. 65) studied with French Cubist André Lhôte and then Albert Gleizes. Later on she began to tire of non-representational work and turned to the technique of stained glass. For the rest of her life she devoted herself to the medium, greatly influenced by the work of Georges Rouault (see p. 48). Like Rouault, she was a devout Catholic. A period of study with Wilhelmina Geddes provided Hone with a sound grasp of the fundamental requirements of stained glass. After her training she worked at the studio of *An Túr Gloine*, a stained-glass co-operative set up by Sarah Purser.

Deposition is a late work in which the artist depicts the moment when the body of Christ has been removed from the cross. His mother and four other figures surround him. Two of these figures are preparing to wrap the body in cloth. The figure of Saint John can be seen in the lower right foreground. Hone's technique differs from that of Harry Clarke (see p. 59), who made extensive use of acid. Instead, she built up contrasts of tone by applying colour to the glass. The simplicity and harmony of the colours belie the deeply expressive quality of Hone's work.

Hone had a successful career with major commissions both in Ireland and abroad. Examples of her work can be found in Eton College Chapel in England and Blackrock College in Dublin.

MC

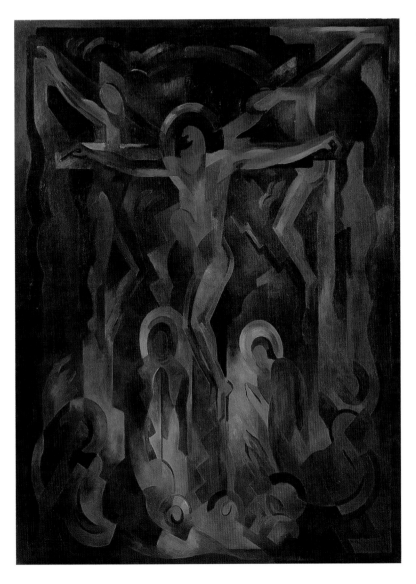

The Ninth Hour is a fine example of Mainie Jellett's works on the theme of the Crucifixion. While her work of the 1920s was abstract, in the 1930s she moved towards a more semi-abstract figurative style. In this late work, the two thieves flank the figure of Christ: Dismas, the Penitent, on the right, and Gesmas, the Impenitent, on the left. At the foot of the cross Saint John, the Virgin Mary, Mary Magdalen and Mary, mother of James, are distinguishable.

There is a flame-like quality to this work achieved by the use of colour, with the red and yellow at the bottom of the image rising to blue and purple at the top. The paint is thinly applied but through her use of geometric shapes Jellett creates a complex surface pattern. She once said, "The surface is my starting-point, my aim is to make it live."

Jellett studied at the Dublin Metropolitan School of Art and then in London with William Orpen (see p. 52) and Walter Sickert (see p. 41). In 1921 she travelled to Paris with Evie Hone (see p. 64) to study under André Lhôte and Albert Gleizes, from whom she learned the theory and practice of Cubism. Mainie Jellett played a leading role in the development and promotion of a modern movement in Irish art.

MC

The Ninth Hour

1941
Oil on canvas
86.3 × 64.2 cm
Signed and dated, lower left,
M Jellett 1941

Presented by Miss Mary Rynne,
1963
Reg. No. 1203

Alexander Calder
b. Philadelphia, 1898 – d. New York, 1976

Sun and Moon

1972
Gouache on paper
76 × 101 cm
Signed and dated, centre right,
Calder 72

Purchased from Oliver Dowling
Gallery, Dublin, 1976
Reg. No. 1421

Alexander Calder was born to artist parents – his father an acclaimed sculptor, his mother a painter – and although his creativity was encouraged from an early age, he qualified as an engineer before committing himself to becoming an artist. This technical skill is strikingly apparent in the mobiles, jewellery and wryly amusing wire sculptures for which he is renowned.

Calder also produced numerous gouaches during his career, preferring the medium to oil and watercolour. Like Mondrian and Miró, Calder uses a bold palette of primary colours and this work is typical of his œuvre. In a palette confined to red, yellow, black and white, the sun and moon are boldly depicted, separated by a diminishing row of yin and yang motifs echoing the forms of the universe. The pronounced two-dimensionality and apparent suspension of the compositional elements give them a weightlessness recalling Calder's mobiles, and illustrate his constant exploration of relationships between juxtaposed forms.

Calder said, "The first inspiration I ever had was the cosmos, the planetary system." *Sun and Moon* appears to reference an inspirational vision Calder had during a voyage to San Francisco in 1922 via the Panama Canal, when he woke on deck to see a large, red sun and bright, silver moon on opposite horizons.

JS

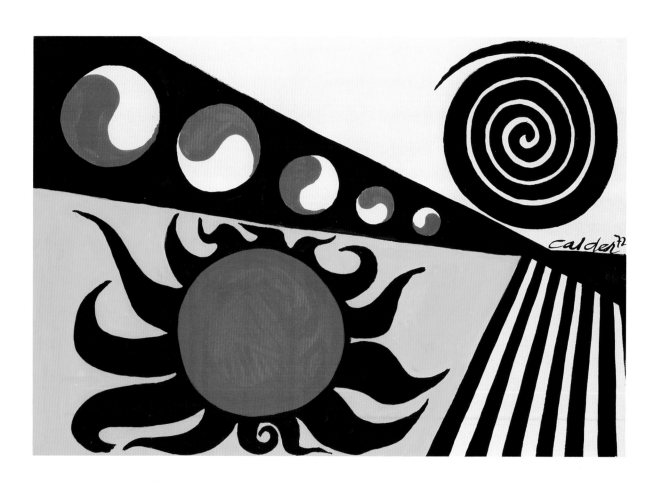

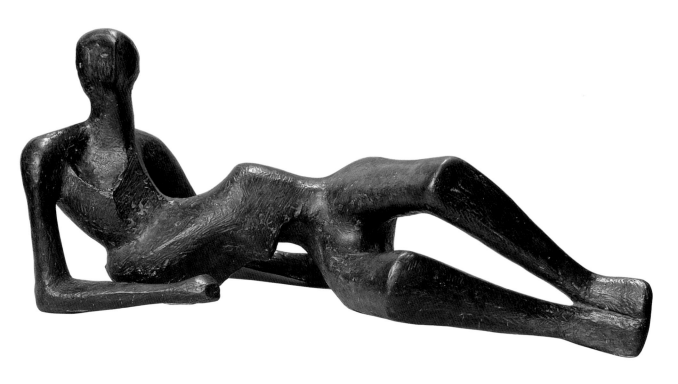

Reclining Figure No. 2
1953
Bronze
40 × 91.5 × 37 cm

Presented by the Friends of the
National Collections of Ireland,
1956
Reg. No. 1064

Henry Moore studied at Leeds School of Art
and the Royal College of Art, London, and
was awarded a travelling scholarship to Italy
and France in 1925. He regarded intense
study of the human figure as fundamental
for the sculptor, and throughout his life
explored a restricted range of figurative
themes, including mother and child, the
reclining figure, and the family group. His
diverse influences include the sculpture
of ancient Greece, Egypt and Mexico, and
also work by such contemporary artists as
Brancusi and Picasso. He was an official war
artist during World War II, and his drawings
of people sheltering in underground stations
during the Blitz are among the sources for
his reclining figures.

Reclining Figure No. 2 tends towards
abstraction, the figure's smooth, nearly
featureless head and hands reminiscent of
foetal forms. It is given tension and vitality
through the various forms, such as elbows,
knees and pelvis, appearing to press
outwards, yet it also celebrates the sensuous
beauty of the body. Moore initially made
holes in sculptures to heighten awareness
of spaces within a figure, but here solid
and void are inseparable and of equal
importance. Superficial detail is avoided
in an attempt to investigate deeper levels
of the unconscious.

JS

Maurice MacGonigal

b. Dublin, 1900 – d. Dublin, 1979

Dockers

c. 1933–34
Oil on canvas
125.4 × 100 cm
Signed lower left, *Mac Congail*

Presented by the Thomas Haverty
Trust, 1935
Reg. No. 765

Dockers is a forthright statement in which Maurice MacGonigal, perhaps better known for his west of Ireland landscapes, reveals his concern for the economically precarious position of the urban working classes. Set against the dramatic red of an ocean-going cargo ship, the three stevedores depicted here await the result of 'the read': a reading of the names of those who would be given work on that particular day. The three 'button-men' whose portraits are painted here were sent by the artist's friend and Trade Union leader James Larkin to MacGonigal's studio to pose for this painting. This deliberate posing indoors may account for the painting's slightly airless quality. The two men facing us had left their native County Clare in search of employment. Where the younger man stares unflinchingly at the viewer, his older companion to the left, though less confrontational, is in his detachment equally dignified. The man with his back to us, from Dublin, appears to be more resigned to the frustrations of this daily ritual. Elected a member of the Royal Hibernian Academy, Dublin, in 1933, and President in 1962, MacGonigal also became Professor of Painting at the National College of Art in 1960.

JO'D

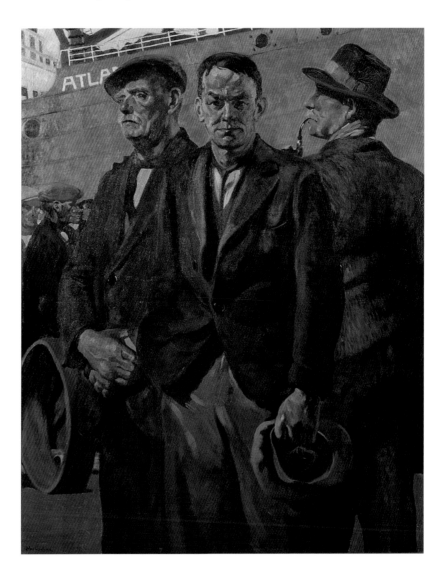

Norah McGuinness
b. Derry, 1903 – d. Dublin, 1980

Garden Green

1962

Oil on canvas

101.6 × 71.1 cm

Signed and dated, lower right

N. McGuinness 62

Presented by the Contemporary
Irish Art Society, 1962

Reg. No. 1197

Norah McGuinness received her early art education in Derry and at the Dublin Metropolitan School of Art, where her tutors included Patrick Tuohy (see p. 63) and Harry Clarke (see p. 59). In 1929 she studied in Paris under André Lhôte, who expounded a decorative form of Cubism. McGuinness's investigation of the interrelationship between objects, depth and perspective is vibrantly and compellingly explored through the still life subject-matter of *Garden Green*. Everyday objects – a cooking pot, two bottles, a cup and saucer, a spoon, a potato and a lemon – seem to sit precariously on a two-dimensional table before an open window. McGuinness's use of blocks of closely related colour tones reflects the stylistic forms of Cubism. The verdant forms are further enlivened by pure, almost luminous areas of white, where the eye is led from the tablecloth further up the picture plane to the white dress of the young girl in the garden. The rigour of the geometric forms is mitigated by the lushness of the colours and such charming details as the climbing roses outside the windowpane. McGuinness was a prominent member of Dublin art society, holding the position of Chairwoman of the Living Art Exhibition for twenty-eight years. JO'D

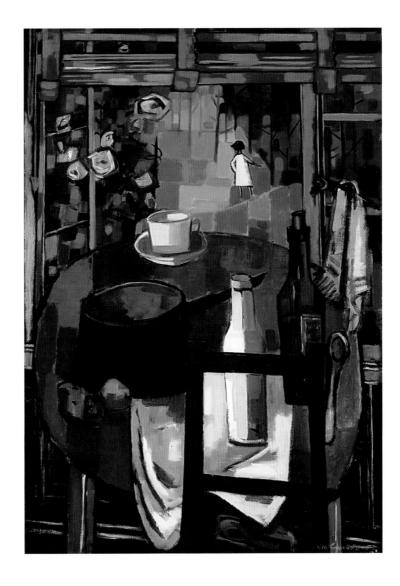

Nano Reid

b. Drogheda, County Louth, 1905 – d. Drogheda, County Louth, 1981

Rubbish Dump

1958
Oil on board
45.8 × 61 cm
Signed, lower left, *Nano Reid*

Kirkpatrick Bequest through
the Friends of the National
Collections of Ireland, 1982
Reg. No. 1484

Nano Reid was born in the Boyne Valley, an area of Ireland with a rich archaeological heritage. For many, the region's ancient structures, such as the Stone Age passage tomb, Newgrange, can exude ancestral memories, and these nurtured Reid's imagination. She did not produce realistic paintings, but rather utilized a form of hieroglyphics to hint at and suggest the reality of the world. She studied at the Metropolitan School of Art in Dublin, and in her formative years she drew much inspiration from the illustrations of Harry Clarke (see p. 59). In the 1920s she went to Paris to attend the Académie de la Grande Chaumière, but she was more enthusiastic about the way the Latin American students "lashed their glowing paint onto their canvases with a free and easy recklessness" than by her teachers, and many of her paintings are covered with wild brushstrokes of sulphurous yellow, placed beside placid blue and ochre. As the majority of her artwork testifies, she abandoned conventional perspective and delineated the many objects in a composition – in this instance, a figure tipping a cart down a hill, with the horse unhitched, a boat in a lake, and birds finding fresh pickings (at bottom right). Reid's pictographs call to mind the images of cave paintings and suggest primeval art brought into the modern era.

PC

b. Banbridge, County Down, 1909 – d. London, 1992

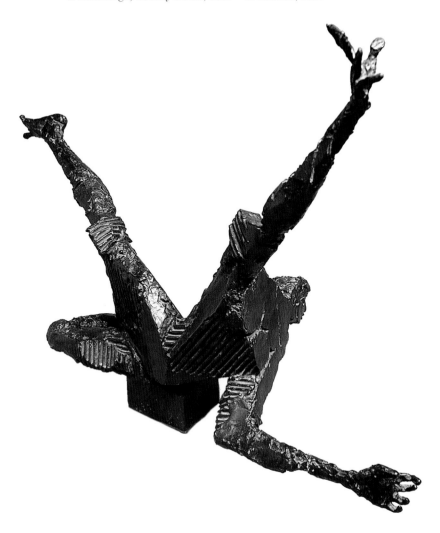

Women of Belfast 1/1972

1972
Bronze
64 × 94 × 31 cm

Purchased, 1995
Reg. No. 1836

F.E. McWilliam was never one to follow any camp, yet the freedom to experiment and love of the visual pun inspired by his early exposure to Surrealism in Paris during the 1930s informed his practice all his life. Among those represented in the 1936 'Surrealism in British Art' exhibition, he became part of an artistic milieu that included Henry Moore (see p. 67), Barbara Hepworth, William Scott (see p. 78) and Patrick Heron. McWilliam eschewed the changing sculptural vogue of the 1960s, remaining true to his own vision and dedication to craftsmanship, and guided by what his materials bid, whether stone, wood or bronze.

Although McWilliam left Northern Ireland when he was eighteen he felt deeply the tragedy of unfolding events there, and when the Abercorn Tea Rooms were bombed in 1971 he responded over the next four years with the *Women of Belfast* series.

Women of Belfast 1/1972, with its ridged surfaces and effect of flattening and turning corners within the figure, shares with the other pieces the violence of the woman's body flung into space: arms and legs are attenuated, splayed and pitted, while garments carve sharp, deep folds about the body, and in some cases also shroud the head as in a Classical funerary frieze.

CK

Francis Bacon
b. Dublin, 1909 – d. Madrid, 1992

*Untitled (Kneeling Figure –
Back View)*

c. 1980–82
Oil and pastel on canvas
198 × 147 cm

Tedcastle Holdings (Fuel
Importers) and the Conlon
family, 2005
Reg. No. 1984

Untitled (Kneeling Figure – Back View) could
stand as a finished work by Francis Bacon,
since all the elements have been channelled
into a compelling and unified statement. It
is clearly related to *Study from the Human
Body* (1983; Menil Foundation, Houston) and
to other works from the 1979 to 1983 period,
when Bacon employed a hot cadmium
orange tone as a background. A nude male
figure, whose head and physique call to mind
Bacon's former lover, George Dyer, is seen
kneeling on a plinth. Another limb, possibly
from another figure, can also be identified.
References to a domestic interior are
included in the shape of a light switch and
bare light bulb.

This is one of six unfinished paintings
by Bacon in the collection. The works span
Bacon's career from the period of his first
major breakthrough in the 1940s to the last
years of his life, when he had attained the
status of the leading figurative artist of his
time. They are unique among his paintings
on public display since in their raw state
they reveal his unorthodox techniques, and
chart his progress from the first exploratory
outlines to the application of intense colour
and expressive modelling. Each work can be
related to other paintings from the painter's
œuvre and several mark important stages in
his development.

MC

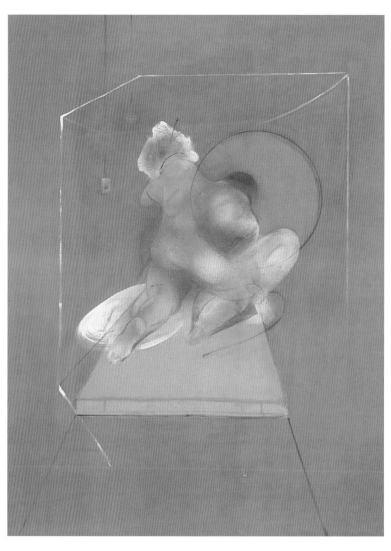

b. Dublin, 1909 – d. Madrid, 1992

Untitled (Final Unfinished Portrait)

1991–92
Oil on canvas
198.2 × 146.7 cm

Presented by John Edwards, 1998
Reg. No. 1919

This unfinished portrait was found on Francis Bacon's easel in his Reece Mews studio in South Kensington, London, on his death in April 1992. The artist's sister, Ianthe Knott, recalls seeing the same work on his easel the previous November, an indication that Bacon's pace of work had slowed down considerably. Nevertheless, he had remained determined to attempt works on this scale.

The figure(s), sofa and framing device have been sketched in with paint on the unprimed surface, and one head has been brought halfway to completion. It is unclear how many figures the artist intended to include in this composition. The circular outline may have been drawn using a dustbin lid, although this was not found in the studio contents. The vertical and horizontal lines framing the composition were probably made with a T-square. As is typical of Bacon's procedure, the background has yet to be laid in. The head of the central figure is the most highly developed part of the canvas, yet even so, the identity of the figure remains elusive. Initially, it was thought to be a self-portrait, an assumption consistent with the sitter's slightly protruding lower lip, yet the stark profile also resembles that of George Dyer, Bacon's dead lover (see p. 72).

MC

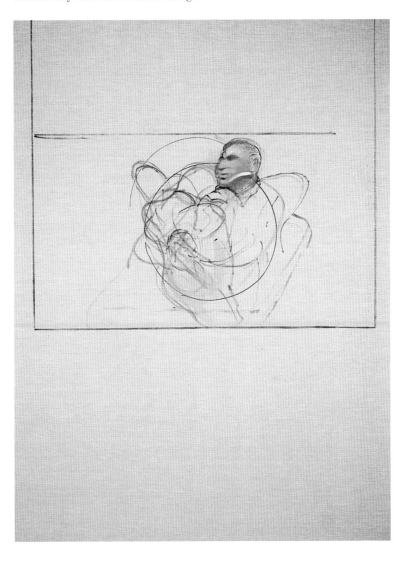

Colin Middleton

b. Belfast, 1910 – d. Belfast, 1983

Anvil Rock III

1968
Oil on board
92 × 89 cm
Monogrammed, lower right

Presented by the Contemporary
Irish Art Society, 1976
Reg. No. 1305

Colin Middleton holds a unique place in contemporary Irish art history because of the vast diversity of his painterly expression. He experimented with almost every form of modern painting technique and ideology, dabbling in Expressionism, Pointillism and Cubism. He was the son of a damask designer and worked for many years in that profession, while frequenting in his early years the Belfast Royal Academy. Middleton was drawn to the art of the Surrealists and produced many figurative works; however, later in his career he looked to the landscape for inspiration and moved towards abstraction. Perhaps the only quality consistently apparent in his paintings is his love of design, since so many of them are notably flat and highly decorative, qualities characteristic of cloth design work. *Anvil Rock III* follows in the tradition of the Constructivists, Picasso's collages and true abstraction. It is a plywood collage with a layer of gesso and painted in tones of beige, brown and charcoal, almost monochromatic when compared to the rest of his œuvre. The gesso creates a subtle surface texture akin to coarse linen. The piece refers to a rock formation in the shape of an anvil that Middleton found on a lake island in Northern Ireland.

PC

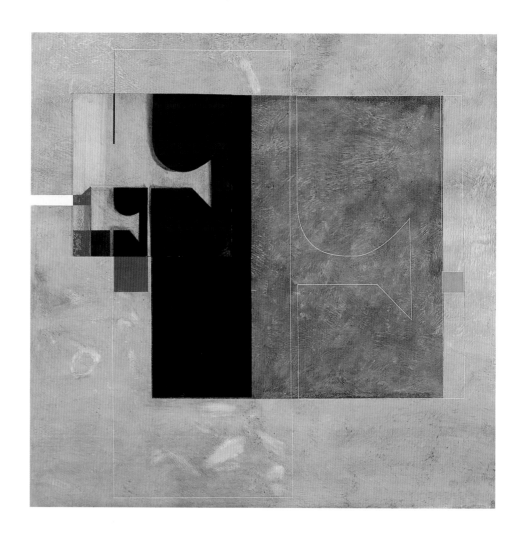

b. Dromore West, County Sligo, 1910 – d. Dublin, 1994

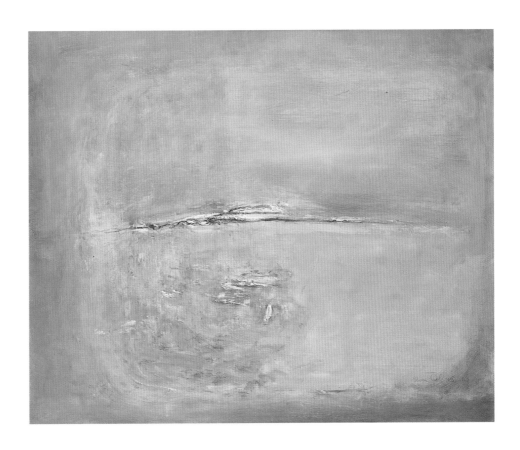

Hy Brazil

1963
Oil on board
75 × 90 cm
Signed and dated, lower right,
Patrick Collins 63

Presented by the Contemporary
Irish Art Society, 1963
Reg. No. 1210

In Irish mythology Hy Brazil is a mythical island out in the Atlantic off the west coast of Ireland. It is a magical realm, neither sea nor land, yet both. According to legend, it is visible every seven years and is known as the Isle of the Living, the Isle of Truth, of Joy, of Fair Women, and of Apples. Other early Celtic legends also say that the island only appears at sunset in the mists of the Atlantic.

In this painting, Collins captures the romantic essence of this mythical place. Using a frame within a frame effect, he provides a tantalizing glimpse of a narrow band of rock indicated by thickly applied pigment, which seemingly floats in a delicate blue-grey mist in the distance. Collins spent his early years in the west of Ireland and had a deep and long-lasting affinity for the Irish landscape. He cited the painter Paul Henry (see p. 51) as one of the main influences on his career. Irish literature was also an inspiration, in particular the works of W.B. Yeats, J.M. Synge and James Joyce.

Collins had very little formal art education and worked in the insurance business for more than twenty years before devoting himself completely to art.

MC

Agnes Martin
b. Macklin, Saskatchewan, Canada, 1912 – d. Taos, New Mexico, 2004

Untitled No. 7

1980
Gesso, acrylic and graphite
184 × 184 cm

Signed on verso
Purchased, 1980
Reg. No. 1446

Agnes Martin's simplified abstract works are internationally renowned. She is one of the great exponents of abstract expressionism in her subtle manifestations of experience through inspiration. Born in Canada, she lived in New York in the late 1950s and early 1960s, sharing a studio for a time with Ellsworth Kelly (see p. 88). Her work rapidly received critical acclaim. In 1968 she moved back to New Mexico, where she had lived from 1952 to 1957; the white light of the desert and its rich earth colours permeate her work. Solely about visual perception, with a complete absence of representational or literary references, this singular work is realized through a lifetime of self-critical appraisal and a commitment to a timeless expression. *Untitled No. 7* was exhibited at

Rosc in 1980. It is a superb example of how her work unfolds with the benefit of time. The feeling of the sublime that the painting engenders is extraordinary, given that it has emerged out of such a rudimentary formal colour composition.

BD

b. Montreal, Canada, 1913 – d. Woodstock, New York, 1980

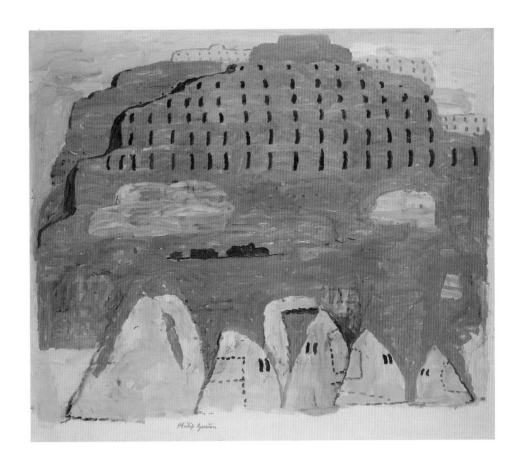

Outskirts

1969
Oil on canvas
165.1 × 190.5 cm
Signed, lower centre, *Philip
Guston*

Purchased from the Estate
of Philip Guston, 2005
Reg. No. 1985

A leading Abstract Expressionist, Philip
Guston shifted dramatically to figuration in
the late 1960s. In a bid to make palpable his
sense of existential doubt, he developed
an iconography that drew on his early life
and the personal universe of his studio.
Recurring motifs include shoes, books,
cigarette butts, clocks, a head with a single
open eye, arms, and bare light bulbs, each
often appearing to mutate into something
else. His repeated depiction of these items
was an attempt, as he put it, to investigate
the "objectness" of ordinary forms.

The Klansmen reference that appears in
Outskirts occurs mainly in the paintings of
1969–70. Involved in strike action at a Los
Angeles factory when he was seventeen,
Guston had first-hand experience of the Ku
Klux Klan when they slashed paintings he
had done of the strike. He portrayed himself
hooded in some paintings, smoking and
painting, "imagining what it would be like

to be evil", and set others in an imaginary
city overtaken by the KKK. Influenced by
the buildings he passed on the West Side
Highway towards New York City, the
receding file of red monolithic structures
in *Outskirts* also recalls the shape of the
fireplace of the New York loft Guston
occupied in the 1930s. It was one of the
paintings exhibited at Guston's famous
exhibition at Marlborough Fine Art, New
York, in 1970, which heralded his return
to figuration.

CK

William Scott

b. Greenock, Scotland, 1913 – d. Coleford, Gloucestershire, 1989

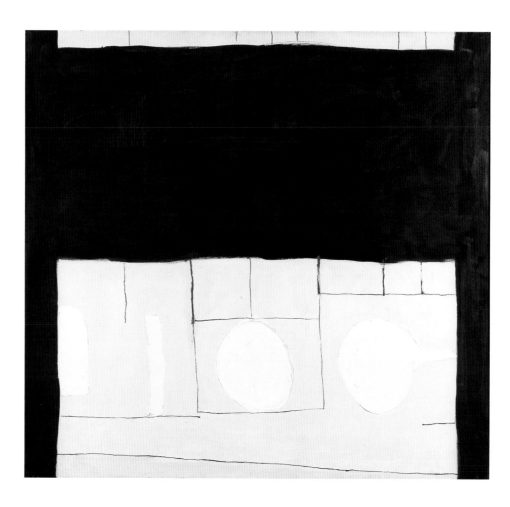

Blue and White

1963
Oil on canvas
157 × 170 cm

Purchased, 1996
Reg. No. 1899

Informed both by the European tradition of painting and by his encounter with the great American Abstract Expressionists, William Scott's work is significant in that it embodies a dialogue between these two practices. In the 1954 exhibition at the Beaux Arts Gallery, London, David Sylvester dubbed Scott and his colleagues Jack Smith, Derrick Greaves, Edward Middleditch and John Bratby the 'Kitchen Sink group', since they seemed prepared to paint anything – including the kitchen sink. This loose group of very different artists, with very different goals, had exponents throughout central Europe, including Renato Guttuso in Italy and Bernard Buffet in France. The concerns of William Scott's earlier paintings filter through his experiences with the large-format, frontier mentality of the American Abstract Expressionists to produce an extraordinary body of work; the genre of still-life painting regains its former relevance and in the process is completely revolutionized.

Blue and White is a perfect example of Scott's synthesis of observation and invention. The austerity is palpable, and the flattened-out pictorial space gives the abstracted pots and pans an elegiac quality.

BD

b. Callan, County Kilkenny, 1913 – d. County Kilkenny, 2003

Mid-Summer Window with Moths 21.6.1992

1992
Oil on board
125.8 × 125.8 cm
Signed and dated, lower right,
Ó'M 6/92, and lower left, *Ó'M*

Purchased, 1992
Reg. No. 1826

Tony O'Malley came to painting relatively late in life, which sparked an instinctive urgency in him to keep painting and not to waste any time. He began while convalescing from tuberculosis, and he continued to paint while working for the Munster and Leinster Bank. After retiring from the bank, he moved in 1960 to St Ives, in Cornwall. The thirty years that O'Malley lived in the creatively conducive environment of St Ives were interspersed with summer visits to Ireland. He also painted in Lanzarote and in the Bahamas, where his wife had family connections.

O'Malley's style developed from early figuration to a lyrical abstraction that was usually grounded in recognizable and recurring motifs. The date on which he painted *Mid-Summer Window with Moths* is physically incised on the surface of the painting and this emphasis on place, date and time reflects his desire to anchor highly evocative, though transitory, moments. Windows appear frequently as a theme throughout his work. This picture, painted in Callan, amplifies O'Malley's visual, sensory and emotive responses to a moment at twilight on a warm summer's evening. The flitting insects are abstracted through his use of scattered patterns set amid earth tones interspersed with highlights of rich colour.

JO'D

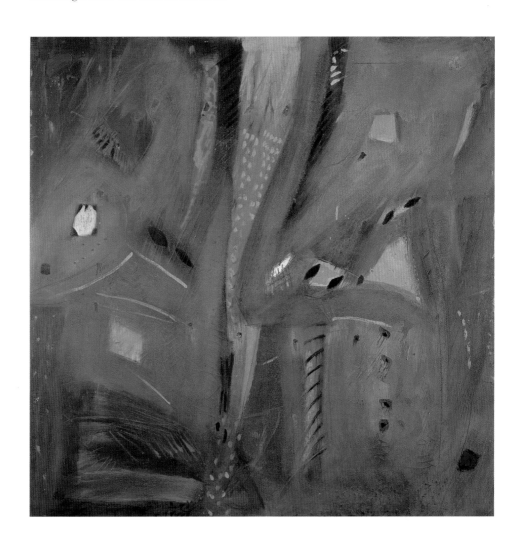

Patrick Hennessy

b. Cork, 1915 – d. London, 1980

Exiles

1943
Oil on canvas
99 × 59.5 cm
Signed lower right, *Hennessy*

Presented by the Thomas Haverty
Trust, 1945
Reg. No. 995

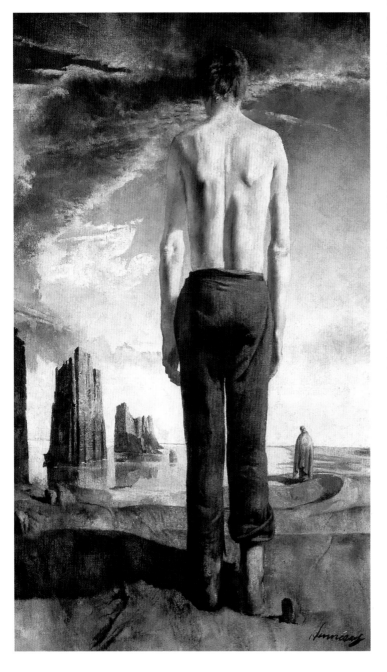

Exiles is a superb example of Patrick Hennessy's distinctive form of realist painting with its Surrealist undertones and air of mystery and intrigue. An elongated male figure presents his back to the viewer as he looks out over an apocalyptic landscape devoid of any vegetation. A cloaked female figure can be observed in the distance. The columns of rock mirror the forms of the figures and the brooding cloud masses that engulf the man's head add to the unsettling atmosphere of this painting. Hennessy's technical accomplishment here is evident in the low-key palette and barely discernible brushstrokes. The title is enigmatic and it is left to the viewer to decide whether Hennessy's subject is emigration in famine-stricken nineteenth-century Ireland or the effects of World War II.

One of Ireland's finest realist painters, Hennessy was born in Cork but as a child moved to Scotland. He later studied art in Dundee before travelling to France and Italy. In 1939 he returned to Ireland and in 1940 joined The Society of Dublin Painters. He divided his time between Dublin and Cork. Over the next thirty years Hennessy showed almost one hundred works at the Royal Hibernian Academy, ranging from interiors and still-lifes, to portraits and landscapes. In his later years he travelled frequently in Europe and North Africa, often spending his winters in Morocco.

MC

b. Belfast, 1916 – d. Dublin, 1971

A Child's World, Belfast

1955
Oil on board
56 × 61 cm
Signed lower left, *Gerard Dillon*

Purchased, 1995
Reg. No. 1887

Although Gerard Dillon briefly attended the Belfast College of Art, he was essentially a self-taught artist who painted in a distinctive and deliberate primitive style. At the age of sixteen he was apprenticed to a painting and decorating firm on the Falls Road. Two years later he left Belfast for London, where he had a number of odd jobs, using spare cash he earned to purchase art materials. During World War II he returned to Ireland. Dillon exhibited often and widely throughout his lifetime and was a long-standing committee member of the Irish Exhibition of Living Art. He also spent time abroad in Italy and Spain. Dillon once remarked that he was "always trying to see with a child's innocence and sincerity" and his subject-matter is sometimes drawn from his own written childhood memories. *A Child's World, Belfast* depicts a young girl on an empty street at twilight and reflects the recurring theme of the individual in isolation in Dillon's work. Surrounded by the chalk remnants of the day's play, as well as political and other graffiti, she casts a lonely figure standing in the hopscotch 'home' while gazing at a drawn outline of a mother and child.

JO'D

Louis le Brocquy

b. Dublin, 1916

Isolated Being

1962
Oil on canvas
152.4 × 91.5 cm
Signed lower right, *Le Brocquy 62*

Presented by P.J. Carroll and
County Ltd through the
Contemporary Irish Arts Society, 1962
Reg. No. 1122

Louis le Brocquy is one of Ireland's greatest artists. Since early in his career Le Brocquy has devoted himself to themes of human isolation within the community. In the 1950s the isolated individual, in relation to the collective human condition, became the focus in his paintings of single white presences, which emerge from a pale ground. In *Isolated Being* the artist attempts to present a universal image and sense of humanity. He dismisses the straightforward representation of human form, seeking instead to evoke its presence, to convey a sense of the psychological as well as the physical essence and thus arrive at a form that universally symbolizes the human condition. Tadayasu Sakai, Director of the Museum of Modern Art, Kamakura, aptly describes this painting in the following terms: "The aim of this work is not to represent the physical structure and physical appearance as well as possible. It is literally to make spirit visible, to evoke a kind of spiritual experience."

Self-taught, Le Brocquy is Ireland's best-known artist. He was a founder member, with Mainie Jellett (see p. 65) and Evie Hone (see p. 64), of the Irish Exhibition of Living Art. In 1956 his painting *A Family* (National Gallery of Ireland) won a major international prize at the Venice Biennale. In 1958 he married the painter Anne Madden (see p. 98) and he has since lived and worked in France and Ireland.

MC

b. Melbourne, Australia, 1917 – d. London, 1992

Kelly at the River

1964
Oil on canvas
120 × 105.5 cm

Presented by the Friends of the National Collections of Ireland, 1984

Reg. No. 1685

Sidney Nolan sporadically attended the National Gallery Art School in Melbourne from 1934 and studied engraving and lithography under S.W. Hayter at the Atelier 17, Paris, in 1957. Just after World War II, he began his great sequence of paintings portraying the escapades of the infamous bushranger Ned Kelly, exploring both the truth and the mythical aspects of the mischievous armoured man. Nolan's simplistic image of Kelly has become an icon for modern Australia.

The depiction of Kelly's saga also gave the artist an excuse to paint the Australian landscape in a truly original manner, while at the same time allowing his views on such universal themes as injustice, love and betrayal to be voiced. The relationship between humankind and the environment is a key concern of the series. In this painting Kelly is a lone figure standing on the banks of a river in a vast sun-scorched, desolate landscape. An outlaw through misfortune and harsh conditions, Kelly turned to crime, as wealthy landowners forced smaller farmers off the meagre arable land available in the outback. Yet from the way his helmeted head leans forward, he appears remorseful for his wrong-doings. Whether Australia's greatest folk hero should be seen as villain or victim is an issue that is hotly debated in modern Australia.

PC

Melanie le Brocquy

b. Dublin, 1919

Sybil le Brocquy

1973
Bronze
34 × 28 × 36.5 cm

Presented by the Sybil le Brocquy
Memorial Fund, 1977
Reg. No. 1429

Initially, Melanie le Brocquy was encouraged by her schoolteachers to pursue a career in illustration and painting. However, at the National College of Art and Design she turned her attention to sculpture. A Taylor Prize scholarship afforded her the opportunity to attend the Ecole des Beaux-Arts in Geneva and to travel to Paris to visit both the Louvre and the Musée Rodin. After a period of absence from art, in the 1960s she began to work in plaster, clay, terracotta and wax, producing works of great originality.

This particular sculpture calls to mind the work of the Italian sculptor Medardo Rosso in the way in which the features are made up of daubs of clay, giving the impression that the more subtle details of the face are forming before the viewer's eyes. The effect is to make clearly visible the creative process. The subject of the work is Melanie's mother, Sybil le Brocquy, and mother of painter Louis le Brocquy (see p. 82). Of greater significance for modern Irish art is the fact that Sybil le Brocquy (1892–1973) was instrumental in setting up the Irish Exhibition of Living Art, an alternative to the Royal Hibernian Academy's annual exhibition, in 1943.

PC

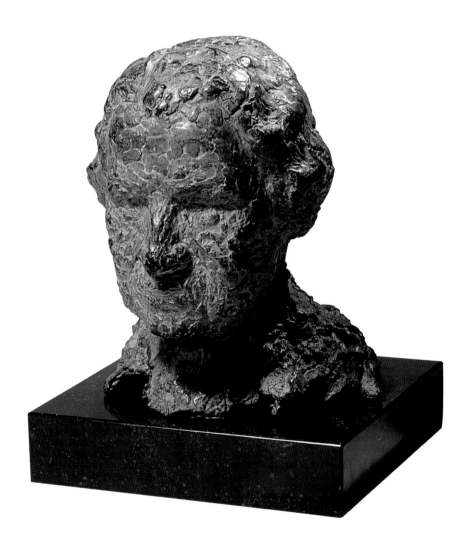

b. Krefeld, Germany, 1921 – d. Düsseldorf, Germany, 1986

The Blackboards, Dublin
1974
Chalk on painted wood, wooden frames
Three pieces, each 89 × 152 cm
Signed on reverse, *Joseph Beuys Dublin 15 Okt.1974*

Presented by the artist following his lecture at Dublin City Gallery The Hugh Lane, during which he executed the drawings, 1974
Reg. Nos. 1356, 1357, 1358

Joseph Beuys's altar-like installation on the windowsill of his workspace featured a copy of *Ulysses* by James Joyce. Joyce was deeply important for Beuys, who even added two chapters to *Ulysses* in the form of drawings in six notebooks. As a result of this influence, Beuys attributed a special significance to Ireland and its people, and in 1974 he came to Dublin to give a lecture in the context of his visiting exhibition of drawings entitled 'The Secret Block for a Secret Person in Ireland'. During the lecture, delivered in Dublin City Gallery The Hugh Lane, Beuys used three blackboards, in triptych form, to draw and notate his ideas. The Dublin bombings had occurred just months before his visit and Beuys offered his lecture and drawings as a form of utopian hope. He championed a pantheon of subjects such as 'Myth', 'Analysis', 'Creativity Art Science', intuition and rational thinking, which combined would result in a socially caring warm 'sun state' – all reconciliations he believed Joyce achieved in *Ulysses*.

Beuys believed that art should not be an exclusive, hermetic system of inward-looking ideas but an integration of all systems of understanding that had the power to make the world a better place, and when in Ireland he set up an Irish branch of the Free International University for interdisciplinary research. CK

Cecil King

b. Rathdrum, County Wicklow, 1921 – d. Dun Laoghaire, County Dublin, 1986

Pendulum

1985
Oil on canvas
183 × 122 cm

Presented by A.W.D. King in
memory of his brother, 1987
Reg. No. 1713

Cecil King first began to paint in 1954 when he was in his early thirties. Initially, his works were semi-abstract paintings of Ringsend and the Dublin Quays, and he also produced a number of still-life and religious pictures. In the early 1960s he became preoccupied with an abstract idiom, and a meeting in 1967 with Barnett Newman, the acknowledged pioneer of colour field and hard-edge painting in the US, proved inspirational. Spatial experience defined by colour became an important element in King's future work. However, despite this move from representational imagery, he took reality as a starting-point.

From 1965 until 1968 he was concerned with the tension and stress of the circus, in particular in the trapeze act, and a series of works on this subject followed. *Pendulum*, an elegant and restrained late work, is also part of a series. The black rectangular form, framed by a band of blue and fine yellow line, recedes away from the viewer. A single line tipped with white swings away, creating a sense of tension between the compositional elements of the work. Despite its deceptive simplicity, there is nothing austere about King's painting, and a sense of warmth is achieved through his handling of colour and use of subtle shading.

King was closely associated with the Rosc international exhibitions, and was a founder member of the Contemporary Irish Art Society.

MC

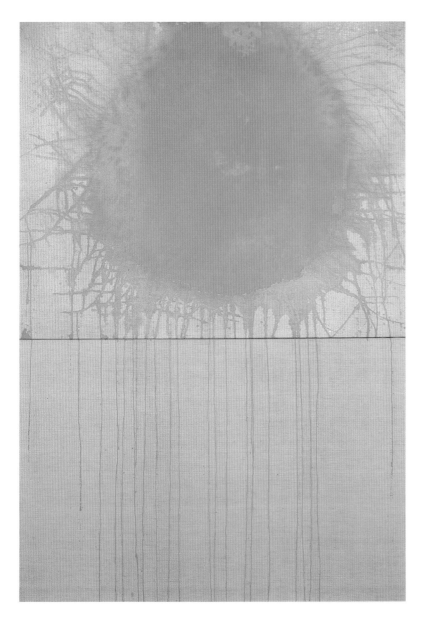

Patrick Scott was one of the great protagonists of post-war painting in Ireland and one of the first Irish exponents of pure abstraction. His early training as an architect has had an enduring influence on a career that spans six decades. In 1960 Scott won the Guggenheim Award and in the same year represented Ireland at the Venice Biennale.

The 1960s saw the artist move into his prime, first with his large *Device* paintings, where his lifelong obsession with the sphere began. *Large Solar Device* is one of a series of paintings in which Scott protested against the H-bomb testing of the day through forms that recall the deadly beauty of the bomb's radiating halo. "The ambiguity of calling them nuclear devices and the reason for still testing weapons of mass destruction, which had already been used with such tragic consequences in Hiroshima and Nagasaki, left me outraged", he said. In common with such paintings as *Yellow Device* and *Purple Device*, colour and ground are integrated to create a dynamic sphere of exploding colour from which radiate rivulets of paint that drip below a strongly defined horizon line. By the mid-1960s the *Device* paintings gave way to the restrained poetry of the abstract *Gold* paintings, today widely regarded as Scott's signature idiom.

CK

Large Solar Device

1964
Tempera on unprimed canvas
234 × 153 cm

Presented by the Contemporary
Irish Art Society, 1964
Reg. No. 1233

Ellsworth Kelly
b. Newburgh, New York, 1923

*Black Relief over Yellow
and Orange*
2004
Oil on canvas
214 × 162.6 cm

Purchased 2006
Reg. No. 1986

Ellsworth Kelly's paintings are the fruit of observations of nature. His unusual take on the natural world, after forty years of painting, is no longer as alarming as it was initially. As an American working in Paris after World War II and as a sophisticated European on his return to New York, his work developed outside the principal movements of the day, L'Ecole de Paris and Abstract Expressionism. Only later, with what became known as 'Post-painterly Abstraction', did his work begin to gain attention.

This pared-down view of the world is by no means minimal in its intention; indeed, what at first may seem parsimonious reveals itself to be a joyful, crystal-clear celebration of objects and places. Secular, free from any quasi-religious justification for ecstasy or revelation, the paintings bear witness to a conscious specific experience that has no meaning outside its visual, haptic quiddity. In this sense Kelly has almost single-handedly brought forward the concerns of Henri Matisse regarding arabesque, line, form and colour.

Black Relief over Yellow and Orange is a perfect example of Kelly's continued investigation into both painting and the real world, and of the astounding consistency of vision that informs all his work.

BD

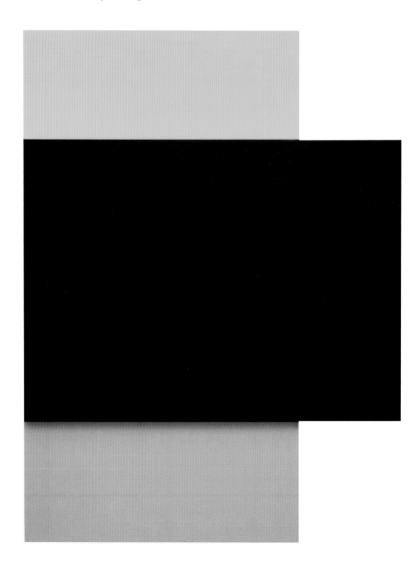

(Edward) b. Washington, 1927 – d. Idaho, 1994
(Nancy) b. Los Angeles, 1943

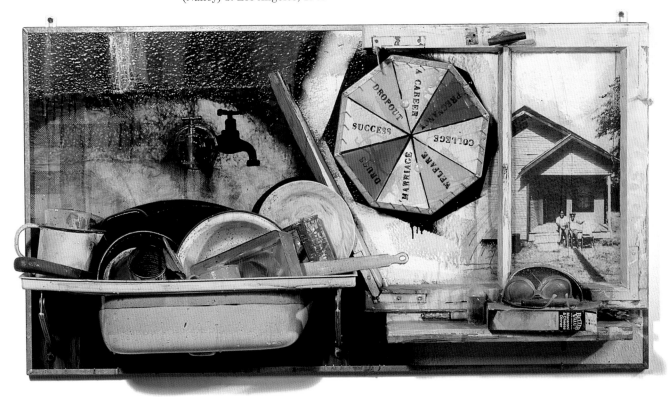

Drawing from "Tank"

1989
Mixed-media assemblage
65.4 × 123.8 × 22.2 cm

Purchased, 1997
Reg. No. 1918

From the 1950s Edward Kienholz used junk to construct compelling, often grotesque, assemblages that comment satirically on the social, political and religious hypocrisy of American life in particular. He worked in collaboration with his wife, Nancy Reddin, from 1972 and *The Merry-Go-World Or Begat By Chance and the Wonder Horse Trigger* was one of the couple's last collaborations before Edward Kienholz's death in 1994.

Drawing from "Tank" is one of the related accompanying tableaux for the life-size walk-in carousel *Merry-Go-World*, which was exhibited at Dublin City Gallery The Hugh Lane in 1996. Its subject-matter is life's lottery and the unequal distribution of the world's wealth. The viewer must spin a wheel of fortune to gain admission. Inside are eight possible life scenarios, one of which will light up when the wheel ceases to spin. *Drawing from "Tank"* relates to one of the eight scenes and is a wall-mounted assemblage of photographs and found objects that tells the story of a young black girl in Houston called Tank who lived with

her mother in a 'shotgun' house – a narrow one-storey dwelling without hall, with the rooms placed one behind another in single line so there was no escape if a shot was fired into the house. The disorderly kitchen sink assemblage is overseen by a mini wheel of fortune, which bodes a variety of potential outcomes for the young girl, from 'career' and 'success' to 'welfare' and 'drop-out'.

CK

Deborah Brown
b. Belfast, 1929

Environment/Waiting

1982
Paper and wire
Various dimensions

Purchased from the
David Hendriks Gallery, 1982
Reg. No. 1563

Deborah Brown is one of the most interesting and avant-garde artist/sculptors of her generation in Ireland. In her early career the landscape painter Humbert Craig was an inspiration, but in the mid-1960s she began to move away from the two-dimensional surface to more sculptural forms. During the 1970s the 'Troubles' in Northern Ireland particularly influenced her work, and her barbed wire and fibre-glass sculptures are a poignant and sobering reflection on her encounters and impressions of that period.

In 1980, chancing on a small figure sitting under a tree in Chicago set in motion one of the most productive periods of Brown's career. Recalling small figures made of wire she had made when she designed stage sets in the fifties for the Lyric Theatre in Belfast, she began to experiment with wire. Her resulting wire and papier-mâché sculptures were critically acclaimed and in 1984 she was selected for inclusion in Rosc. *Environment/Waiting* is a sculptured audience waiting for a Punch and Judy show to begin. The tension between the slightly grotesque subjects totally indifferent to each other and the suggestion of forthcoming entertainment is both comical and unsettling.

In 1982 a major retrospective of her work was held at the Ormeau Baths, Belfast, the Orchard Gallery, Derry, and Dublin City Gallery The Hugh Lane. BD

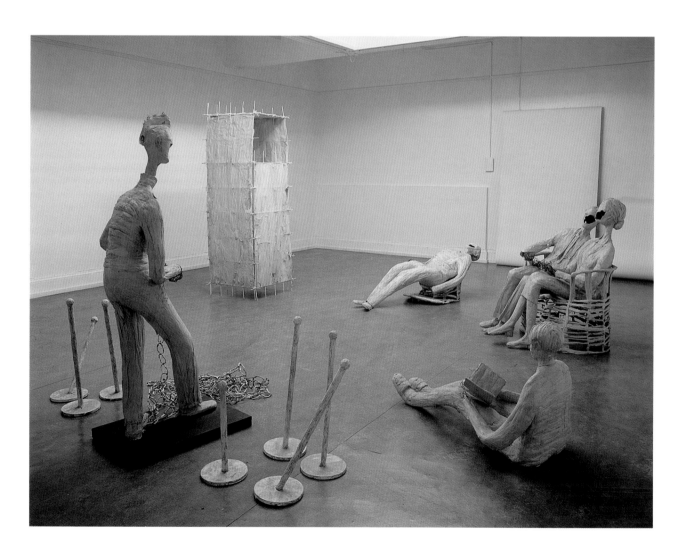

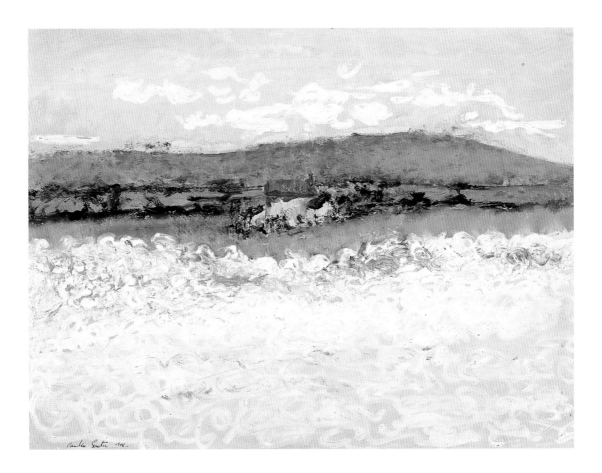

Waiting to go on the canal

1968
Oil on board
56 × 76.2 cm
Signed lower left,
Camille Souter 1968

Presented by the Contemporary
Irish Art Society, 1969
Reg. No. 1294

Camille Souter was born in Northampton but moved with her family to Ireland in 1932. A self-taught painter, she originally trained as a nurse and worked in London but then turned to painting in the 1950s while recuperating from an illness. She was especially inspired by paintings by Pierre Bonnard (see p. 43), which she had seen in London in 1947. Souter's chief subject-matter is landscape and still life. She takes the most banal, ordinary or sometimes unusual subjects (such as the circus or slaughterhouse), and makes something lyrical from them. Painting only in natural light, she requests that her paintings only be viewed in that light.

One of three works by Souter in the Gallery's collection, *Waiting to go on the canal* belongs to a series of canal paintings from the 1960s and 1970s. It is almost abstract in style, with the canvas divided into rich bands of colour and texture. At the centre of the composition is a farmhouse set against the backdrop of a hilly strip of land. In the foreground, agitated swirls of paint build up into a foaming mass, providing the painting with a strong tactile quality.

Souter has lived and worked in Dublin, Wicklow and Italy and currently lives on Achill Island. She is a member of Aosdána. Her work displays an originality of response that singles her out as one of the great Irish landscape painters of the modern era.

MC

Terence P. Flanagan
b. Enniskillen, County Fermanagh, 1929

Bogwater and Bullwire
c. 1975
Oil on canvas
183 × 213 cm
Signed, *T.P. Flanagan*

Purchased, 1998
Reg. No. 1913

Equally at ease with oil and watercolour, T.P. Flanagan is one of the most celebrated Northern Irish painters of his generation. His practice has made his name synonymous with the landscapes of the north-west of Ireland and the Lagan Valley.

The Northern Irish 'Troubles', which took a particularly bloody turn in the early 1970s, gave rise to a number of paintings of psychological intensity that pay homage to those who lost their lives in the violence. *Bogwater and Bullwire* is the most monumental of these works. A strand of barbed wire is strung low across the foreground as though to separate the living from the underworld. Beyond, a light fog covers the bare, calcified hills, punctuated here and there by bleached fence posts like grave markers in the landscape. The sense of the sacrificial here is both profound and poignant. Yet a glimmer of hope of rebirth and regeneration survives in the two vertical bright-green slashes, like blades of grass, caught on the wire above a water-filled hole in the soft loamy bog.

A major retrospective of Flanagan's paintings took place at the Ulster Museum and Dublin City Gallery The Hugh Lane in 1996.

CK

b. Neuilly-sur-Seine, France, 1930 – d. San Diego, California, 2002

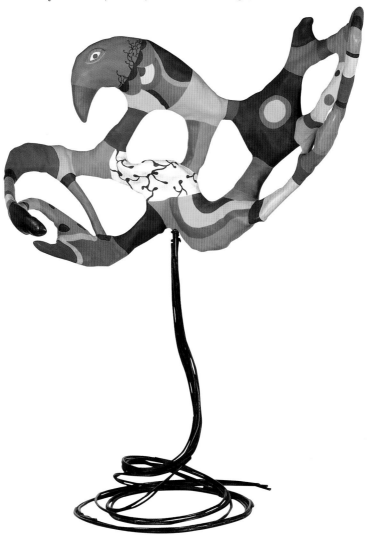

Big Bird

1982
Polyester polychrome
160 × 150 × 99 cm

Purchased from the Gimpel Fils
Gallery, London, 1983
Reg. No. 1677

Although born in France, Niki de Saint Phalle spent her formative years in New York. A self-taught artist, her work from its inception was informed by deeply personal points of reference as well as a diverse range of artistic and anthropological sources, which subsequently developed into an exuberant and subjective mythology. Gaudí's *Parc Guell* (1900–14; Barcelona) was particularly influential and inspired her to create monumental, high-spirited figures in playground and garden settings. Her shooting paintings, or '*tirs*', of the early 1960s, which involved firing weapons at paint-filled assemblages leading to explosions of colour, brought her to prominence and she became a member of the Nouveau Realistes, a French avant-garde group that included Christo (see p. 101) and Yves Klein. Her use of liquid polyester, a medium enabling curvaceous and polychromatic sculptures, resulted in her contracting emphysema. During her period of convalescence the theme of air came to the fore. *Big Bird* belongs to a body of work from the early 1980s she called *Skinnys* and described as 'air sculptures'. Birds were personally symbolic for her and recur frequently throughout her work. *Big Bird*'s kinetic energy is heightened by its polychrome, coiled lead and the numerous voids through which the spectator can see.

JO'D

Edward Delaney

b. Claremorris, County Mayo, 1930

Bronze Groups

c. 1968
Bronze
Heights 100 cm and 92 cm
(including bases)

Presented by Maurice Fridberg, 1975

Reg. Nos. 1368 and 1369

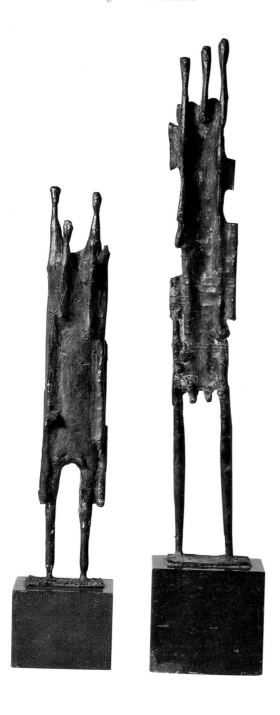

Edward Delaney left school aged fourteen, but later attended the National College of Art, Dublin. From 1954 to 1961 he studied sculpture in Munich and Rome, then worked in numerous foundries across Europe. He learned many professional practices and set out to master the tradition of lost-wax bronze casting (a process whereby a wax model is encased in clay, heated, and molten bronze poured into the void left by the wax). Delaney became highly proficient in this technique, prized for its ability to retain the fine detailing of the original wax model.

The *Bronze Groups*, made at the peak of Delaney's career, marry themes that had long fascinated him: the standing, elongated human figure, also explored through the figure of Cuchulainn and the crucified Christ, and the family group. In these bronzes, however, the figures are rendered abstract: single entities that can also be read as multiple figures. Delaney endows them with a delicacy and vulnerability, the elongated structures evoking a lightness that is at odds with the weight and bulk of their material. The smooth texture of the multiple heads references the soft wax of the original modelling, and Delaney succeeds in communicating a sense of the tenuousness and uncertainty of the human condition.

JS

b. Schonberg, Czech Republic, 1931 – d. Dublin, 1975

Gerda Frömel's premature death at the age of forty-four meant that her output was limited. Nevertheless, the quality of her work remains unsurpassed in its sensitivity to materials. Under her hand, alabaster, bronze, marble, slate, steel and aluminium revealed their innate character, which Frömel ingeniously held in tension in the realization of each piece. The influence of Brancusi is perceptible in her heads, often of sleeping children, where forms are insinuated to the point of near abstraction.

Animal and Hunter is one of a series of works from the early 1960s invoking nature with reference to birds, trees, streams and waves. The form of the bronze itself suggests a nestling wild animal. On it is lightly etched the figure of a recumbent deer in a landscape, the presence of which is evoked by the interplay of textures and patina, which also makes the piece look worn and vaguely ritualistic. The hunter's presence is unarticulated but pervasive. As with all of Frömel's works, the surface attracts a play of light that seems to cling to forms rather than define them.

Frömel settled in Ireland in 1956 after studying in Stuttgart, Darmstadt and Munich, and regularly exhibited in the Irish Exhibition of Living Art. She was married to the sculptor Werner Schürmann, with whom she had four sons.

CK

Animal and Hunter

c. 1963
Bronze
48 × 56 × 7.5 cm

Presented by the Contemporary
Irish Art Society, 1964
Reg. No. 1235

Barrie Cooke
b. Cheshire, 1931

Sheela-Na-Gig

1962–63
Mixed media on board
122 × 127 cm

Presented by Mr Mack Kile
through Sir Basil Goulding, Bart.,
1976
Reg. No. 1489

One of Ireland's most respected artists, Barrie Cooke trained as a painter in Austria and the US, and has lived in Ireland since 1960. This work is one of a series of paintings based on sheela-na-gigs: medieval stone carvings of grotesque female figures with exaggerated genitalia thought to relate to ancient fertility rituals. There are several in Ireland, many of them situated in churches.

Cooke acknowledges the paradox of such sexualized figures appearing in ecclesiastical contexts in a country that had, in the past, pronounced sexual taboos. He is especially interested, however, in these exhibitionist fertility symbols' ability to embody the force of the landscape in which he situates them, reflecting his continual exploration of key personal themes that include regeneration, decay, fertility and sexuality. In *Sheela-Na-Gig* the figure is roughly modelled from unglazed clay, jutting from a barren, semi-monochrome landscape of smeared concrete and dripped paint, on to which rocks are collaged, conveying a raw, primitive energy.

Cooke has expressed an interest in situating mythical figures in real landscapes, but his sculptural treatment of this subject gives it a physical presence, rooting it firmly in reality. Headless, its limbs truncated, the sheela-na-gig becomes a universal mother god evoking the more fundamental idea of mankind's inextricable link to the land, its rhythms and its force.

JS

Portrait of Francis Stuart

1974
Oil on canvas
80 × 67.2 cm
Signed and dated, lower right,
1974, Edward McGuire

Purchased from the Dawson
Gallery, 1975
Reg. No. 1404

Edward McGuire is best known for his portraits of literary figures and also for his still life paintings. A trip to Florence and Rome in 1951, where he encountered the work of the Italian masters Giotto and Piero della Francesca, proved to be a formative experience. In 1954–55 he attended the Slade School of Fine Art in London where he met Lucian Freud, whose work he admired.

The sitter for this painting was the poet and novelist Francis Stuart (1902–2000). Born in Australia but brought up in Ireland, at the age of eighteen Stuart eloped with Iseult MacBride, daughter of Maud Gonne, who was W.B. Yeats's muse. During his lifetime, Stuart's literary successes were overshadowed by controversy regarding an alleged sympathy with the Nazis in World War II, an accusation he always denied.

Stuart recalled that this painting was done partly from photographs but there was a number of sittings at McGuire's house towards the end of the work. McGuire placed great emphasis on the technical aspects of the painter's craft, and he was a painstakingly slow and meticulous artist. This contributes to the static, almost austere quality of his work. The giant leaves outside the window recall the Surrealist works of René Magritte.

MC

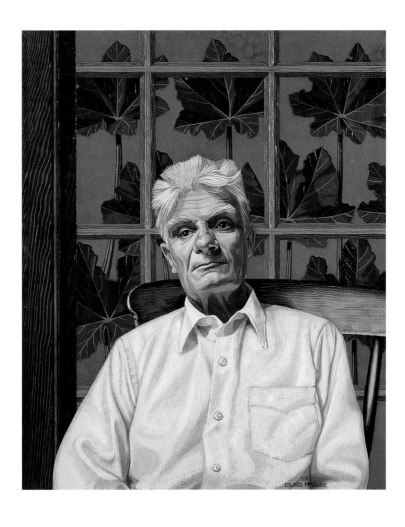

Anne Madden

b. London, 1932

(Icarus) Plummet

1997
Oil on canvas
195 × 114 cm

Presented by the artist 1997
Reg. No. 1915

Anne Madden is a central figure in the story of Irish abstract painting. Although she spent her early years in Chile she became familiar with the Irish landscape, particularly the Burren in County Clare, where she spent her teens. Her work is greatly influenced by place, especially ancestral and ancient sites, and this inspiration is a conduit for a unique articulation of light, colour and form. In the 1960s, following a period at Chelsea Art School in London, her light-filled fluid paintings of rock and land formations won her critical acclaim, and in 1964 she was the first recipient of the Carroll's Award at the Irish Exhibition of Living Art. In the following year she represented Ireland at the Paris Biennale.

Following on from her megalithic paintings of the 1970s, Madden embarked in the 1980s on a series of works inspired by Pompeii. This was after a visit to the ancient site, which moved her deeply: not only the evident destruction of the people but also the particular shapes and sensations of the ruined spaces frozen in their time.

In 1997 Madden held her first solo exhibition in Dublin City Gallery The Hugh Lane. 'Trajectories' consisted of two sequences of paintings, *Odyssey* and *Icarus*. Using a rich palette including gold, a colour that was recently adopted by the artist, the quest for adventure and discovery is played out on different levels. A mythological desire to transcend existing limits in a search for new experiences finds sympathy with the artist, who wrestles with the discovery of the painting within the composition. In *Plummet*, the gold is wayward, surface-bound, creating balance and tension between surface and colour, the depths of which create limitless expanses of sky realized in vivid blues, through which the fallen Icarus hurtles to his inevitable demise.

BD

Niall's Pony

1997
Oil on canvas
138 × 123 cm
Signed, upper right, *Blackshaw*

Purchased, 1998
Reg. No. 1914

Basil Blackshaw's rural upbringing and his lifelong dwelling in the countryside of Northern Ireland reverberate throughout his painting. From 1948 to 1951 he attended the Belfast College of Art, contributing to the cost of his art education with income from his paintings of horses. In 1951 he was awarded a government scholarship that enabled him to travel to Paris and London. Blackshaw has consistently painted subjects that reflect his everyday life, particularly the farming community to which he belongs. Both his father and brother worked with horses, and dogs and cockerels are also recurring themes in his art. While valid subjects in their own right, occasionally his animals or landscapes also express human psychological conditions. His diverse artistic influences include Degas (see pp. 26–28), who had a similar love of horses, Bacon (see pp. 72–73), Courbet (see p. 18) and Mark Rothko. Blackshaw's œuvre, which encompasses portraits and figurative painting as well as illustrative work for Field Day Theatre Company, oscillates between representation and abstraction. The expressive and painterly style of *Niall's Pony*, together with its richly glowing colour, invests the work with remarkable vitality. The painting is also typical in the way the focus is on a single motif placed against a simple though thickly painted background.

JO'D

Brian O'Doherty/Patrick Ireland
b. Ballaghadereen, County Roscommon, 1928
Since 1972 makes art in the name of Patrick Ireland

The Rake's Progress

1970
Aluminium on wood
183 × 21.5 cm

Purchased, 1986
Reg. No. 1705

A qualified medical doctor and emerging artist when he left Dublin in 1957, Brian O'Doherty moved to New York, where he is celebrated as one of the pioneers of Conceptualism. He continues to explore key themes: language, perception and identity. He changed his name to Patrick Ireland in 1972 to protest against the killing of Derry civilians by British soldiers known as 'Bloody Sunday'.

The Rake's Progress is one of the series of *Ogham* sculptures made between 1967 and 1971. Ogham is a pre-Christian Celtic script that consists of four sets of four lines variously arranged across a single line. Using Ogham allowed the artist to conflate matters of language, serialism and minimal-conceptualism in a single form to express his pared-down vocabulary: 'ONE', 'HERE', and 'NOW'. The words chosen stand for his preoccupying concepts of self and location.

This piece is wall-mounted, 1.8 metres (6 feet) high and W-shaped in section, the chamfered points of the 'W' resting flush with the wall. Its wooden core is thinly sheeted with polished aluminium, the reflective property of which allows viewers to contemplate their location, notions of self and the script's visual play. The word 'HERE' is represented throughout this sculpture by an S-shaped line, the basis of all natural beauty as postulated by the eighteenth-century engraver and painter William Hogarth in his series *A Rake's Progress* (1735).

CK

b. Gabravo, Bulgaria, 1935

Wrapped Walk Ways Project for St Stephen's Green Park, Dublin

1977
Fabric, pencil, photostat from photograph by Wolfgang Volz, charcoal, crayon, pastel, map and four black-and-white photographs by Wolfgang Volz
Collage in two parts:
each 71 × 56 cm
Signed upper centre,
Christo, 1977

Purchased by the Friends of the National Collections of Ireland and Dublin Corporation, 1978
Reg. No. 1438

Christo Javacheff attended the Academy of Fine Arts in Sofia from 1953 to 1956 and the following year briefly studied in Vienna. In 1958 he moved to Paris where he met Jeanne-Claude Denat de Guillebon, who became his wife and artistic collaborator. From his early career Christo sought to provoke new insights into commonplace objects by wrapping them. Initially small in scale, these '*empaquetages*' evolved into ambitious projects that included wrapping large swathes of coastline and well-known landmarks and buildings. In 1976 Christo was invited to participate in Rosc. Christo and Jeanne-Claude's work around this time was informed by ceremonial gardens of the Far East, particularly their subtle change of surfaces underfoot. *Wrapped Walk Ways Project for St Stephen's Green Park, Dublin* is a preparatory work for this unexecuted project, which proposed covering paths in St Stephen's Green with 12,550 square

metres (15,000 square yards) of fabric. Although their fabric paths appeared delicate and ephemeral, Christo and Jeanne-Claude intended people to walk on them. Deliberately situating these beautiful and challenging projects outside a traditional museum context exposes them to a wider audience and their construction often benefits from the involvement of teams of workers drawn from the local community. Despite the complex logistics involved, these striking works are designed to be strictly temporary. In 1978 Christo and Jeanne-Claude created *Wrapped Walk Ways, Loose Park, Kansas City, Missouri.*

JO'D

Brian Bourke
b. Dublin, 1936

Self-portrait in Blue Hat

1965
Oil on canvas
127 × 114.4 cm

Purchased from the Taylor
Gallery, 1982
Reg. No. 1469

Brian Bourke has steadfastly adhered to his own style of painting without being swayed by contemporary developments. He spent a year at the National College of Art in Dublin but dismissed formal art education and felt that he could learn more from studying the work of other artists in museums and galleries. In particular, he admired the handling of colour and composition by fifteenth-century Italian and German painters and he was also impressed by O'Conor (see p. 40) and Bacon (see pp. 72–73).

This is one of the earliest in a series of self-portraits in which the artist depicts himself wearing incongruous headgear.

In this case he wears a blue top hat, introducing an absurd element into what is otherwise a serious work. The modelling of the body in brown and beige hues is in stark contrast with the matt grey and black background. It serves to heighten the definition of the figure and to focus all attention on him. Francis Bacon's influence is evident in the placement of the figure in an unidentifiable spatial setting, and in the way the figurative element of the work is built up with thicker applications of paint. The painting also calls to mind the early self-portraits of Van Gogh.

MC

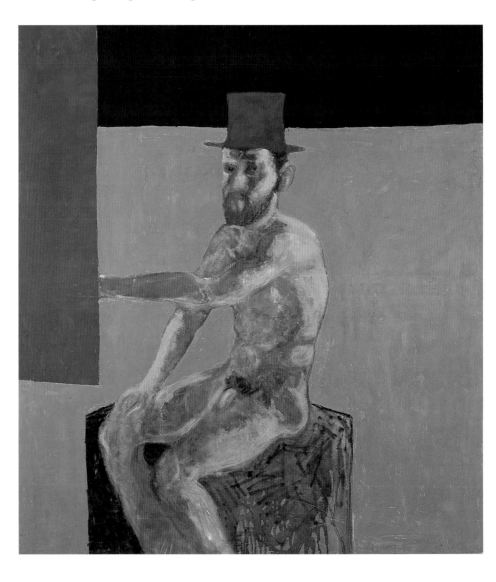

b. Longford, 1939

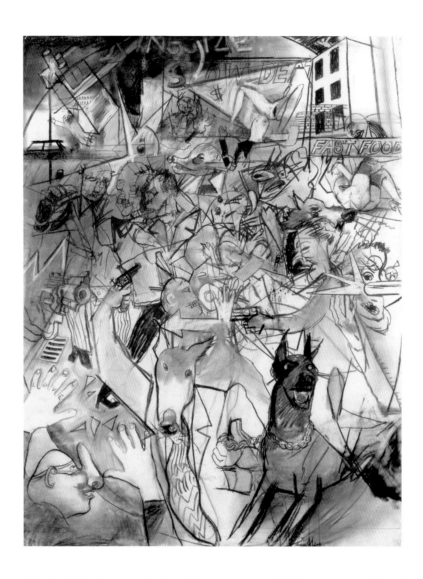

Interesting Times
1984
Mixed media on paper
145 × 111 cm
Purchased, 1997
Reg. No. 1912

Charles Cullen is a superb draughtsman whose artist's eye provides insights into urban life. Working mainly on an intimate scale, he excels at portraiture and successfully conveys a variety of emotions with an economy of means and a use of line that one writer has likened to an exposed and sensitive nerve. A major influence on all his output has been his obsession with 1930s German art and photomontage, especially that of Georg Grosz and Horst Janssen, whose imaginative explorations into the grotesque have impressed Cullen.

Interesting Times is one of a number of works from the 1980s that are characterized by a Dadaist cacophony of nightlife excesses and dissolute characters. Violence as a subject features overtly in Cullen's work of this period, not just through the presence of guns, knives and Rottweilers but also through the distortion of images, fractured composition and obsessive slashing and jittery lines. *Interesting Times*, like much of Cullen's work, also acknowledges a debt to the images and sensations of 'Nighttown' from the 'Circe' chapter of James Joyce's *Ulysses* (1922).

Formerly Head of Painting at the National College of Art and Design, Cullen had a major mid-career retrospective at Dublin City Gallery The Hugh Lane in 1997.

CK

Micheal Farrell

b. Kells, County Meath, 1940 – d. Cardet, France, 2000

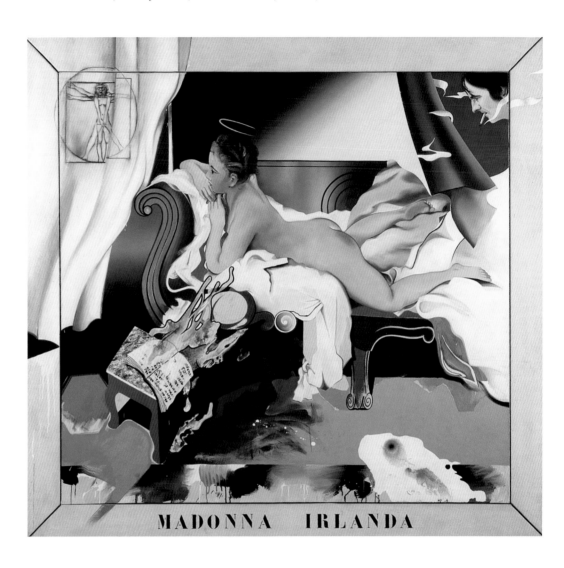

MADONNA IRLANDA

Madonna Irlanda or
The Very First Real Irish
Political Picture

1977
Acrylic on canvas
174 × 185.5 cm

Purchased, 1977
Reg. No. 1436

Micheal Farrell was regarded as one of the most promising artists of his generation. In 1957 he enrolled at St Martin's College of Art, London, then at the forefront of contemporary art in Britain. His international reputation was enhanced by a growing number of prizes and scholarships. From 1971 he resided in France. Farrell's style oscillated between figuration and abstraction; his return to a figurative style in the mid-1970s was prompted by his desire for more direct statements relating to contemporary events, particularly atrocities linked to the 'Troubles' in Northern Ireland. Heretofore these had been articulated through his semi-abstract *Pressé* series.

Madonna Irlanda quotes directly from François Boucher's painting *Resting Girl* of 1752 (Alte Pinakothek, Munich), which depicts Miss Louison O'Murphy, the Irish mistress of Louis XV. Farrell uses Boucher's erotically charged pose to depict a haloed and youthful Mother Ireland with her spelling book to one side, observed by a lascivious male – here a self-portrait. The idea of a young Irish state stunted by violence, immaturity and inertia is reinforced by Farrell's distortion of Leonardo da Vinci's *Study of Proportions* (*c.* 1487), a classic symbol of harmony, into a distraught figure contorted by fear.

JO'D

b. Ballaghadereen, County Roscommon, 1941

Clara and Dario (second version)

1982
Projected images (16 mm) with recorded narration, Olwen Fouere and Roger Doyle (piano)

Purchased, 1986
Reg. No. 1706

James Coleman is one of Ireland's greatest contemporary artists. Since the 1970s he has been exploring the creative possibilities of audio-visual technology, and this has resulted in brilliant and innovative slide and video installations. Addressing issues of perception, he has moved from works in which the human presence is implied to those in which people are the focal point. His art examines the ambiguities that exist in how we see and hear the world and recall experience.

Clara and Dario was the first film work purchased by the Gallery. It is the second version of a work of the same title that Coleman made in Italy in 1976. While the first version consisted of two simultaneous slide projectors in continuous cycle with synchronized audiotape, this work is on looped film. Clara and Dario are dressed in early twentieth-century costume and their images are projected in an oval format. They are separated and a couple. Our interpretation of the relationship changes as the conversation unfolds, recalling an earlier experience they had in Lake Como and their desire to return. Past and future are fused in the present through a dialogue that is partly conducted in the third person, and their future plans and past experiences are discussed in the present tense. The conflicting recollections of a shared memory define their individuality. As in all James Coleman's work, the apparently simple presentation belies its conceptual complexity.

BD

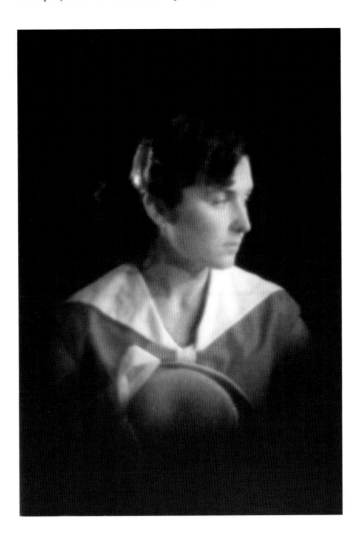

Barry Flanagan
b. Prestatyn, Wales, 1941

*Horse, Mirrored: Sheep Boys:
Cow Girls*

1995
Bronze
(Sheep boys)
146.7 × 106.7 × 40.6 cm
(Cow girls)
154 × 105 × 40.6 cm

Gift from the artist, 1996
Reg. No. 1891

Best known for his triumphant bronze hares that spring into life, Barry Flanagan has attracted attention since his first show in 1966 at the Rowan Gallery, London, held while he was still a student at Central Saint Martins. His first bronze, *Leaping Hare*, was cast in 1979, a move away from his earlier use of such everyday materials as sand, hessian, felt and light. The change of materials marked a culmination in his questioning of material and sculptural form. Influenced by the ideas of dramatist Alfred Jarry, notably 'pataphysics', or the science of imaginary solutions, Flanagan fuses the everyday and the fantastical, moulding and gripping the clay to create a form that offers itself to our imagination.

Flanagan's use of animals, such as hares, or elephants and horses, as in this work, invests the animal world with human attributes, referencing the conventions of the cartoon. The sketchy quality of his technique transforms the work so that it appears always in motion and thus subject to change. The horse, archetype of Classical sculpture, symbolic of fertility, and in particular man's constant companion, here mirrors itself, male and female.

Flanagan represented Britain at the Venice Biennale in 1982. He lives and works in Dublin, London and Ibiza.

GJ

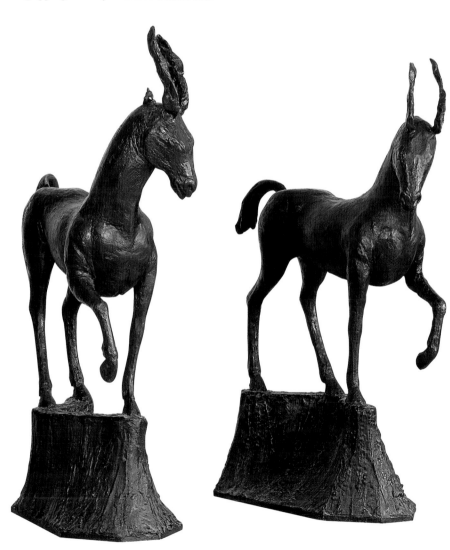

b. Dublin, 1943

The Third of May –
After Goya

1970
Acrylic on canvas
168 × 223 cm
Signed on reverse, *Robert Ballagh*

Elizabeth McDonnell Bequest,
1972
Reg. No. 1324

This painting is adapted from *The Third of May 1808,* (1814–15; Prado, Madrid), a powerful work by the Spanish artist Francisco de Goya. King Ferdinard VII was restored to the Spanish throne in 1814 after the French occupation (1808–14) and Goya painted for him this now famous scene of the bloody uprising of the citizens of Madrid against the occupying forces.

Together with Ballagh's adaptations of works by Jacques Louis David and Eugène Delacroix, this painting forms part of a series that refers directly to events in Northern Ireland. In interview in 1979, the artist explained that he adapted these images into a poster style by simplifying them and keeping the original composition. He stated, "the lines that I drew were kept a constant thickness so that they would not have any personal expressive quality. In other words, the lines could never be gestural or in any way romantic".

Ballagh studied architecture before beginning to paint in earnest around 1967, when he assisted Micheal Farrell (see p. 104) with an important mural commission for the National Bank, College Green, Dublin. Ballagh's own work from that time embraces the abstract idiom. He later found that too restricting and changed to figurative imagery, which characterizes his work to date, and he is best known for his portraits and self-portraits. He is also a noted graphic designer, photographer and designer of stage sets.

MC

Patrick Graham

b. Mullingar, County Westmeath, 1943

Ire/land III

1982
Oil on canvas
183 × 122 cm

Purchased from the Lincoln
Gallery, 1982
Reg. No. 1477

From a very young age, Patrick Graham showed a facility for drawing. He was awarded a scholarship to the National College of Art and Design and graduated in 1964. While his talent was highly regarded, the accolades bestowed did not sit well and he struggled through periods of despair. He has said that his paintings "come from silence and a world of abandonment". An experimental approach and technical mastery are hallmarks of his painting, and the philosophy of Heidegger and paintings by Piero della Francesca, Giotto, Emil Nolde and the masters of early Modernism are among his diverse influences. The earthy colours and memories attached to the landscape surrounding his grandparents' farm also endure in his work. The theme of religion is prevalent, and obviously so in the grimly ironic work *Ire/land III* where Graham confronts ambivalent religious and political beliefs, particularly in relation to the extreme violence of the 'Troubles' in Northern Ireland. Here a draped corpse, like a sacrificial victim, is starkly raised on a bier-pedestal. A shamrock, a symbol both for Ireland and the Holy Trinity, unites the portrait triptychs of Catholic and Republican icons: the Sacred Heart, Catherine McAuley, founder of the Sisters of Mercy, and the Virgin Mary; and the revolutionary heroes James Connolly, The O'Rahilly and Wolfe Tone.

JO'D

b. Dublin, 1945

Figure in Grey
2004
Oil on canvas
299.7 × 256.5 cm
Presented by the artist, 2006
Reg. No. 1989

Sean Scully is renowned as one of the greatest exponents of abstract painting. He studied and worked in England until 1972 when he was awarded a fellowship to Harvard University. In 1975 he settled in New York and now divides his time between New York, Barcelona and Munich, where he is Professor at Akademie der Bilden Kunste, Munich. Scully continues to use a restricted visual language with unique and astonishing virtuosity. His work has evolved from the thin vertical and horizontally striped grid paintings of the 1970s, through to wide bands of colour realized in broad brushstrokes, as is evident in *Figure in Grey*. The shallow picture planes of his early works have given way to a greater openness and light and air seep through the softened edges of his blocks of colour that nudge up against each other. The dynamic between solidity, space and luminosity has altered. The structure remains resolute and stable but the appearance of the underlying colours hints at mystery, leaving the dialogue open-ended. This splendid recent work is part of a prestigious gift of paintings that Sean Scully has presented to the city to mark the opening of the Gallery's new wing. BD

Michael Cullen

b. Kilcoole, County Wicklow, 1946

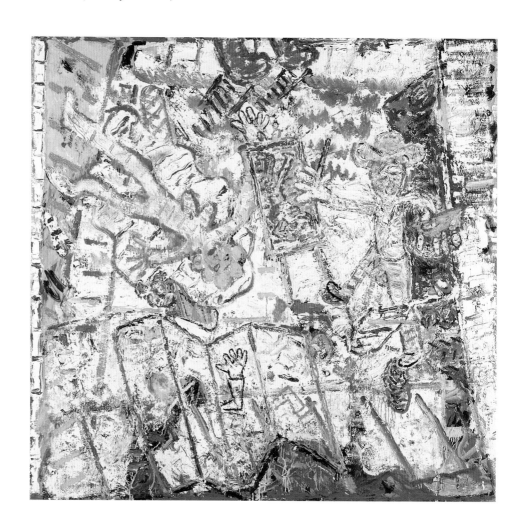

I'm Popeye the Painterman
1992
Oil on canvas
223 × 228 cm

Purchased, 1993
Reg. No. 1827

Michael Cullen had become a painter before he began studying at art schools in London and Dublin. He won a series of Arts Council bursaries from 1977 to 1984 and has exhibited internationally from this time. Disenchanted by perceived limitations in Irish art of the 1960s, Cullen moved abroad after art college and has spent extended periods in Spain, Germany, Morocco and France.

I'm Popeye the Painterman, one of a series of paintings depicting the artist at work, exemplifies Cullen's continuing investigation into the activity of painting itself. Cullen's self-portrayal is informed by Van Gogh's self-portraits on his way to work, and the picture also references 'high art' conventions – for example, the widely explored motif of the artist and model in the studio – while it simultaneously undermines such traditions. The title and cartoon-like handling introduce self-mocking notes, and Cullen's studio is a riot of colour and form. The paraphernalia from which paintings are, literally, manufactured is actively emphasized and, freed from traditional rules of perspective, compositional elements appear to float incongruously. Cullen has remarked, "there are no lace ruffs in a Rembrandt", and by loading the canvas with thick peaks of paint and pigment he deliberately stresses the physicality of his 'ingredients'.

JS

Camac XIII

2002–03
Left: acrylic on copper
56.5 × 37.5 × 6.5 cm;
Right: acrylic on gesso mounted
on copper
49 × 39 × 6.5 cm

Purchased, 2003
Reg. No. 1972

Ciáran Lennon has been painting in Dublin for over thirty years, and has created a body of work of extraordinary singularity. His is an independent practice that has flourished away from the centres of Modernism. Lennon's process is both analytical and spontaneous, and this contradiction gives his work its power and mystery. While the process is always visible, the effect is never straightforward; our assumptions about painting are questioned, as the work is both transparent and mysterious.

Ciáran Lennon's concern with seeing reveals a space initially explored through physically folded structures, which, in his seminal works *The Scotoma Group,* is replaced by optical differentiations.

'Scotoma' is a medical term for fields of vision that are non-functional (i.e. blind spots), and Lennon presents us with three big paintings (2.43 × 3.65 metres / 8 × 12 feet), "big enough for a person to walk into", where the large diagonal brushstrokes fold over one another. The artist's reference to early Renaissance painting and its corporal dimension presents a singular articulation on form. This clarity of vision and absence of rhetoric are manifest in *Camac XIII*. In this painting the folds are replaced by a semi-transparent strata of colour, allowing access to the painting process and coaxing its viewers into a collaboration or dialogue; they thereby become participants in the visual experience. BD

Charles Tyrrell

b. Trim, County Meath, 1950

Untitled

1981
Acrylic and mixed media on
panel
196 × 122 cm

Purchased, 1981
Reg. No. 1465

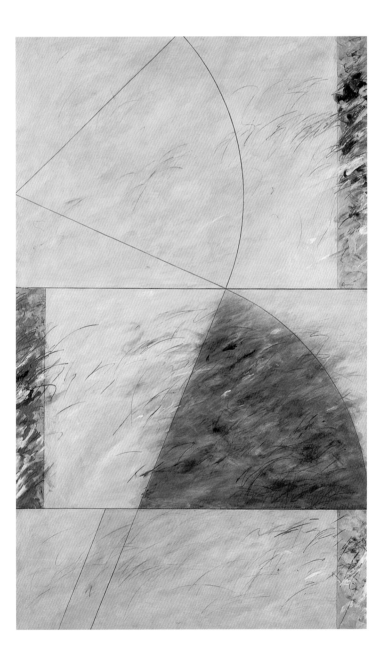

The abstract painter Charles Tyrrell graduated from the National College of Art and Design, Dublin, in 1974. He represented Ireland at the International Festival of Painting at Cagnes-sur-Mer in 1981 and became a member of Aosdána in 1982. Influenced initially by American Abstract Expressionism, specifically the work of Mark Rothko, Willem de Kooning and Morris Louis, he then moved towards Minimalism. His paintings eventually became a fusion of the two styles. Geometry became the structuring force of the composition and the ensuing chaos animated the canvas.

Tyrrell looked to the Irish landscape for inspiration. He felt that pure abstraction was an impossible feat. The lines, cutting the picture plane into sections, hold the wilder brushstrokes in check, the short waving streaks appearing like blades of grass moving in the breeze. The colour, though contained, still manages to diffuse beyond the constraining lines, just as humanity continually attempts to control the natural environment while these controls are in turn constantly pushed aside by nature. Furthermore, the painting portrays the nature of abstract art itself, as the artist endeavours to curb the power of raw creativity with geometry while at the same time desiring to liberate his art from all constraints, both physical and mental.

PC

Michael Warren

b. Gorey, County Wexford, 1950

After Image

1984
Irish Oak
Vertical: 284 × 61 × 91.5 cm
Horizontal: 72 × 221 × 78 cm

Purchased from the Solomon
Gallery, Dublin, 1986
Reg. No. 1694

Working in wood, steel, concrete and stone, Michael Warren is preoccupied with space, gravity, weight and balance. He was apprenticed to sculptor Frank Morris in Wicklow before studying in Milan from 1971 to 1975. However, it was his introduction to Eduardo Chillida's work that has had the greatest impact on him. The Spanish sculptor's relationship to his materials, in particular his large timber sculptures with their perfect pitch between weight, mass and balance, was revelatory for Warren. He went on to explore a unique sense of presence in his own work, exploring opposites and contradictions: lightness conveyed by weight, equilibrium by imbalance, human presence through non-figurative expression.

After Image is one such example of Warren's wood sculptures, and was exhibited at the Rosc in 1984. Crafted from Irish oak, it was subsequently allowed to weather outdoors to encourage warping, cracks and staining. This reflects Warren's preoccupation with the wild, knarled nature of wood and the concept of it being fashioned into austere, disciplined forms.

Michael Warren has been commissioned to make site-specific pieces in countries all over the world, including France, Spain, Andorra, Japan and Taiwan. The sensibility of his work is informed by his particular response to actual place, historical connotation and philosophical reference.

BD

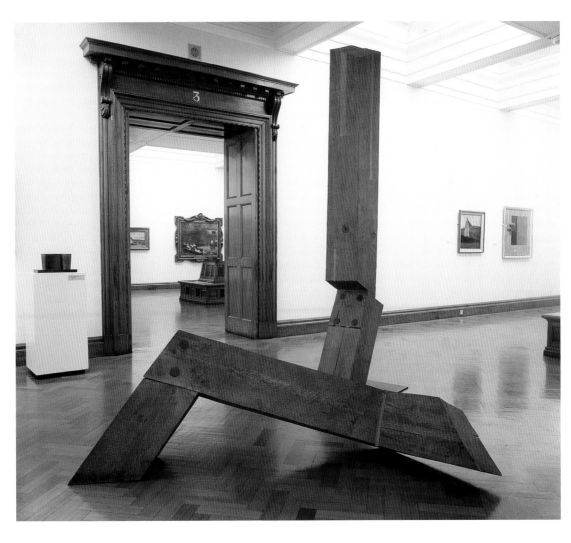

John Kindness

b. Belfast, 1951

Monkey and Dog

1986
Glass mosaic, steel armature,
reinforced plaster
70 × 80 × 80 cm

Purchased from the artist, 1996
Reg. No. 1890

On graduation from the Belfast College of Art in 1974, John Kindness worked professionally as a graphic designer before moving on to large-scale painting and sculptural installations in the 1980s. His work frequently contains irreverent satirical representations of the two opposing factions in his native Northern Ireland.

In *Monkey and Dog* Kindness uses animal allegory to encapsulate the bitter sectarian conflict between Catholics and Protestants. A Republican dog is locked in combat with a Loyalist monkey. The artist's choice of animals was suggested by an eighteenth-century print of Mrs Midnight's performing animals in which a monkey town is besieged by dogs. The image reminded him of depictions of the siege of the city of Derry.

The eternal circular stalemate depicted leaves no possibility of resolution, with the animals inextricably intertwined and evenly matched. The circular format of this sculpture is inspired by Japanese *netsuke* (small, intricately carved toggle fastenings), and allows the sculpture to be viewed from any angle. Although much of Kindness's work contains modern social and political commentary, he often harnesses traditional methods to express his creative talent. The beautifully patterned mosaic coating and elegant curvaceous forms of the animals belie the potency of the subject-matter of the work.

MC

b. Dublin, 1951

*The Foundation Stones
(Mental Home)*

1990
Acrylic on canvas
202 × 170 cm
Signed and dated, verso,
B. Maguire 1990

Purchased, 1993
Reg. No. 1828

State-sanctioned political and social injustice and institutional coercion of the human spirit are grist to Brian Maguire's mill. Renowned for highly expressive gestural painting, in recent years the artist has added billboard posters, photography and video to his prodigious and celebrated œuvre. Maguire's sources are various, from extended art residencies with Loyalist and Republican prisoners and women prisoners of a New York medium-security prison, to his renowned body of work *Casa di Cultura*, which arose from his interaction with São Paolo's *favelas* and prisons, and with which he represented Ireland in the twenty-fourth São Paolo Biennale in 1998.

The Foundation Stones (Mental Home)

questions society's attitudes towards the mentally ill and their marginalization. The image of a receding institutional corridor is based on the cellars of St Patrick's asylum, Dublin, founded by Jonathan Swift. It appears inscribed by a down-turned face, as of one whose life it has eclipsed. The inhumanity of the situation and visceral content of the image are given all the more potency by Maguire's elegiac use of colour, the areas of yellow and green perhaps suggesting the patient's inner struggle to reconcile actuality and memory.

Maguire has been Professor of Fine Art and Head of the Faculty of Fine Art at the National College of Art and Design since 2000. CK

Michael Mulcahy

b. Cork, 1952

Do-gong 10

1993
Diptych, oil and acrylic on canvas
Each panel 162 × 130 cm
Signed left panel, lower left,
M. Mulcahy

Purchased, 1994
Reg. No. 1832

Journeys – both to far-off places and of the mind – are prevailing themes in Michael Mulcahy's work. On completion of his studies at the Crawford School of Art, Cork, and the National College of Art and Design, he travelled in 1973 to north-west Africa, where he lived and worked for two years. Since then he has spent several periods in other countries, including Australia, Papua New Guinea, Mali and India. His sensitivity to and immersion in the colours and psyche of the landscape and cultures he encounters have found eloquent expression in his painting. In 1991 he travelled to South Korea where he spent a year in the Monastery of Ck'uksoam. There he was the student of Su-an Sumin, a renowned Buddhist poet and painter.

Do-gong 10 is part of a series of seventeen similarly named, richly coloured and evocative paintings from this period. Meaning 'Empty Island, Clear Sky',

'Do-gong' was the name given by Su-an to Mulcahy. In order to rid his mind of unnecessary distractions, Mulcahy was set the rigorous task of writing his name 10,000 times, and of drawing circles day after day. The swirling, vibrant brushstrokes of *Do-gong 10* placed against a glowing background are suggestive of a spiritually animated Oriental landscape.

JO'D

b. Strabane, County Tyrone, 1952

Estuary

1995
Acrylic and wax on canvas
194 × 253 × 20 cm

Purchased from the Kerlin
Gallery, Dublin, 1998
Reg. No. 1952

Felim Egan began his art training at Ulster Polytechnic before moving on to study at the Slade School of Fine Art, London. He won a scholarship to attend the British School in Rome in the late 1970s. Throughout his artistic life, Egan has produced mainly minimalist abstract works. His painterly vocabulary comprises the line and the curve, harmonized and balanced with meticulous care. From a distance the lines in *Estuary* appear smooth; however, on closer examination they become sculptural, with their rough undulating edges. Egan's use of such basic pictorial elements lends his paintings a primitive quality, similar to the first human art, imbued with a sense of mystery and harking back to the dawning of creativity. The sea-green background combined with the brushstrokes and wax creates the impression of an aerial view of an estuary as fresh water mixes with the sea. The lines appear like isolated boats approaching a pier and the coloured circles act as buoys bobbing about in a vast expanse, helping to guide the boats across the canvas.

PC

Janet Mullarney

b. Dublin, 1952

Dietro le Quinte

1997
Polychrome wood
154 × 54 × 40 cm

Purchased, 2000
Reg. No. 1956

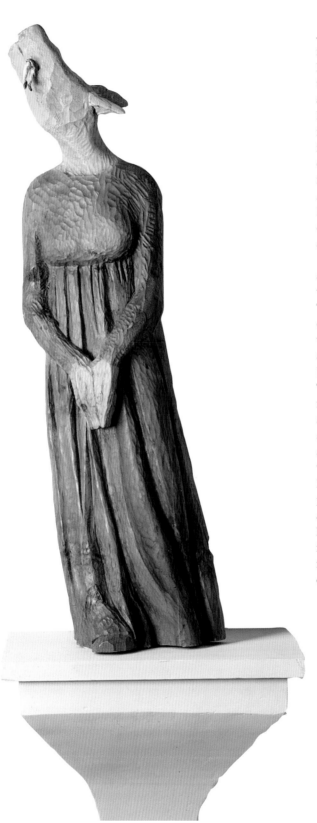

Janet Mullarney's sculpture and installations, which centre around the human form, draw on sources ranging from thirteenth-century Italian polychrome sculpture to the carved gods of India. Mullarney uses a variety of materials including wood, plaster, mixed media and found objects. Her innate talent for carving draws on her earlier experience as a furniture restorer. She studied at the Academia de Belle Arti and the Scuola Professionale di Intaglio in Florence and continues to live and work in both Ireland and Italy.

Dietro le Quinte is part of a substantial suite of work entitled *The Perfect Family*, which was exhibited at Dublin City Gallery The Hugh Lane in 1998 and which continued a theme prevalent in Mullarney's work: the exploration and comprehension of self through a continual questioning of background, religion, society and family. The ironically titled *The Perfect Family* is reflected through a series of domestic gods, some playful and supportive, others with a sadistic, negative twist where all is not as it seems. *Dietro le Quinte*, which means 'behind the scenes', is a dog-headed Madonna figure, hewn from wood and painted, whose jaws close around the legs of a small human figure as it disappears down her throat. According to the artist, the work is "an attack on hypocritical holier-than-thou figures who in private are capable of cannibalization".

CK

James Scanlon
b. Brosna, County Kerry, 1952

Study No. 2 for Miró
1985
Stained-glass panel
52 × 27 cm

Presented by the Contemporary
Irish Art Society, 1986
Reg. No. 1696

James Scanlon studied sculpture and film before embarking on a self-taught stained glass apprenticeship from 1978 to 1981, culminating in the establishment of his own glass studio. Like Harry Clarke before him, he has striven to revive stained glass making, attracting international acclaim for his work.

Study No. 2 for Miró, an early piece, recalls medieval manuscripts with its intimate scale and intense, jewel-like colours but was, in fact, prompted by Miró's *Constellations* series, which demonstrated to Scanlon the great impact that small-scale works could make. Though contemporary in appearance, it derives in fact from traditional techniques, whereby multiple layers of coloured glass 'flashed' together are etched to remove specific areas, layer by layer. The masterfully precise craftsmanship reveals the rich palette of hues inherent in the combined layers, and panels of etched glass are sometimes superimposed, further extending the aesthetic possibilities. Working on a small scale Scanlon avoids the need for the supporting leads commonly found in stained glass.

This piece exemplifies the resulting luminosity and vibrant colour, here combining layers of red, blue, yellow and pink glass. A range of strikingly subtle effects is achieved, with some colours flowing into one another as delicately as watercolours while others remain architectonically hard-edged.

JS

Hughie O'Donoghue
b. Manchester, 1953

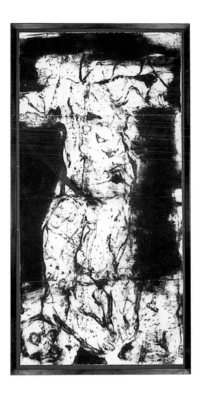
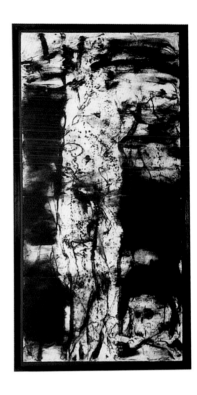

Study for a Crucifixion I, II, III

1996
Carborundum etching
Each 206 × 106 cm
Signed lower right,
H. O'Donoghue

Purchased from the Rubicon
Gallery, 1997
Reg. No. 1906

Internationally acclaimed artist Hughie O'Donoghue is best known for his exploration of the human form. He revels in the fact that art is no longer constrained by the Church or State, nor remains merely a method of recording events. He seeks to create an image of reality, a picture that "authentically corresponds with its subject and with the painter's own sense of the truth". His subject-matter is taken from the inhumanity of man throughout the ages: massacres, wars and torture. These three etchings are primarily concerned with the depiction of the human figure subjected to an appalling form of punishment. The bodies are mutilated with black striations hiding all but the most dominant physical features, and these slashes, in many places, develop into wounds. Each body is surrounded by black, the arms are cut by the picture's edge and only parts of the legs remain visible, while the heads are utterly indistinguishable thus making the images universal: these figures could be anyone.

The artist wants the viewer to experience the feeling of vulnerability, to consider the humiliation and the knowledge of impending death that a victim of crucifixion would feel, and at the same time the thoughts of the onlookers when they realize how fortunate they are not to be hanging on a cross.

PC

b. Cork, 1953

Soundings
1999
Cast bronze, 19 pieces
Various dimensions

Purchased, 1999.
Reg. No. 1960

Vivienne Roche is renowned for her architectonic public sculptures and the finesse with which she manages a variety of materials: progressing from her early loyalty to steel, she went on to explore the diversity of textures and sensibilities offered by bronze, brass, glass and sailcloth. While the nautical world has always been an influence, her heightened awareness of the sea since moving to Garrettstown near Kinsale in the mid-1990s reawakened in her a sense of its imaginative potential and evoked memories of earlier experiences of the Scandinavian landscape during her extended travels there.

The sounds of the ocean, the ebb and flow of the tides, the water-ridged sand, and most literally the embracing forms of the seaweeds cast up on the shore were the inspiration for *Soundings*. It is one of four suites of work in bronze collectively titled *Tidal Erotics* and created in collaboration with a specially commissioned musical score by composer John Buckley. The artist coated the seaweed forms directly in wax, and they were then cast. The resulting bronzes were sensitively patinated to evoke the myriad hues of the shore. The nineteen pieces are on an intimate scale, some lone, others paired, and insinuate areas of human experience. Wall-mounted, their arrangement flows like musical notation around the gallery walls, intended to reiterate the orchestral, cyclical flow of nature.

CK

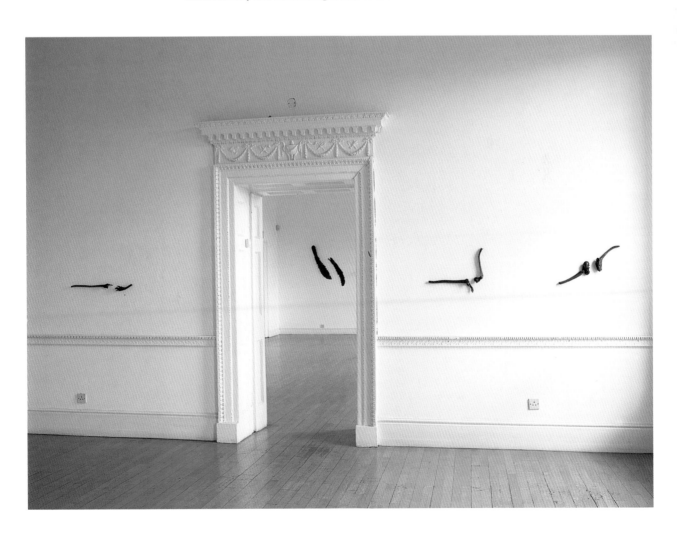

Eilís O'Connell
b. Derry, 1953

*From a Place No Longer
Imagined*

1995–96
Stainless steel and steel cable
330 × 54 × 54 cm;
30 × 253 × 30 cm

Purchased from the Green on Red
Gallery, Dublin, 1997
Reg. No. 1902

Even during her years in the Crawford College of Art and Design, Cork, Eilís O'Connell was fascinated by the vast number of prehistoric sites scattered across the Irish landscape. Originally noticed in Ireland for her large public sculptures, mainly found in urban locations, she has acquired a particular understanding of the nature of public art. She has always been conscious of the fact that such work has to weather the elements, withstanding both natural and human erosion, hence her use of steel; her work thus emulates archaeological remains that have stood the test of time.

O'Connell has proclaimed a desire to marry the organic with the inorganic, and this can be seen clearly in her juxtaposition of polished steel, which has a definite industrial quality, and cable, which has the appearance of rope. The shape of the horizontal piece harks back to ancient utensils and the upright calls to mind the image of standing stones. There is simplicity of form: a tall structure with a section missing, a cross between a carved stone and the trunk of a tree struck by lightning planted beside the complexity of thousands of steel wires twisted around each other to create an organic texture. PC

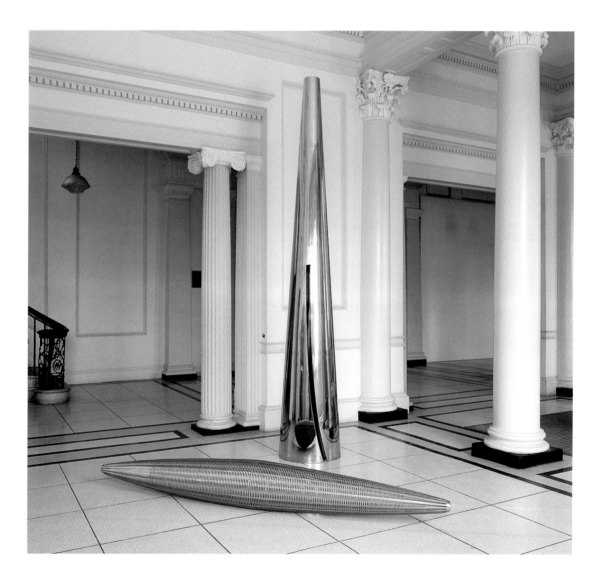

Dorothy Cross attended the Crawford Municipal School of Art, later studying 3-D design at Leicester Polytechnic and silversmithing in Amsterdam. She uses an eclectic range of materials in her work, including finely wrought silver, found objects, video and musical performance. With these, she develops long-established interests in such issues as gender, sexuality, authority and eroticism, seeking to challenge traditionally accepted stereotypes and conventions associated with them. She draws frequently on Jungian and psychoanalytical theory in her exploration of human identity.

Shark Lady in a Balldress confronts us with apparent contradictions. Powerfully symbolic, sharks are commonly seen to signify threat, aggression and fear. They are also generally assumed to be male. Here, the 'aggressor' turns out to be female and protrudes from a delicate ballgown of woven bronze, although she is also ambiguously phallic, with breasts readily interpreted as testicles, referencing Jung's anima/animus theory. Perhaps she is 'dressed to kill' – we are certainly tempted to acknowledge the pun. The work is both grotesque and endearing, repellent and wittily amusing, but succeeds in providing a strong challenge to traditional presumptions of dominance and aggression as male qualities, and the female as docile, and essentially a passive object of desire. Dorothy Cross is one of Ireland's most renowned contemporary artists.

JS

Shark Lady in a Balldress
1988
Bronze
110 × 70 × 70 cm
Purchased, 1992
Reg. No. 1825

Alice Maher
b. Cahir, County Tipperary, 1956

Familiar II

1994

Oil and acrylic on canvas, bronze

244 × 141 × 6 cm

Presented by DHL, 1996

Reg. No. 1888

Following her studies in Limerick, Alice Maher attended the Crawford College of Art from 1981 to 1985 and gained her MA in Fine Art from the University of Ulster in 1986. As a Fulbright scholar she completed a postgraduate fellowship in painting at the San Francisco Art Institute from 1986 to 1987, and in 1994 she represented Ireland at the São Paulo Biennale. Maher's imaginative transformation of objects from real life – bees, berries or hair, for example – invests her pieces with richly diverse layers of meaning, which articulate her own personal mythology and childhood memories, or engage with art-historical or cultural references. Maher has spoken of the lack of seeing that can sometimes occur through over-familiarization, and her working process encourages the distillation of thought through deliberate repetition.

Familiar II combines both painting and sculpture and plays with the viewer's perception of objects seen from afar and up close. A bronze head of a sleeping girl, situated some distance away and minuscule by comparison, points in the direction of a large painting depicting disjointed labyrinthine hedges with emphatic three-dimensionality. While the painting could be seen to visualize the interior universe of the bronze head's psyche, the pairing also raises questions regarding the delineation of spatial boundaries. JO'D

b. Kilkenny, 1957

Shame
1996
Mixed-media installation
180 × 280 × 300 cm
Presented by DHL, 1997
Reg. No. 1907

While Patrick O'Reilly briefly studied in the Belfast College of Art from 1975 to 1976, he is in essence a self-taught artist. His work is characterized by beautifully crafted, visually imaginative and sometimes humorous sculptural pieces. He has wittily adapted familiar objects in order to comment, often sympathetically, on the banality of existence or the insidious collusion of society in acts of cruelty. O'Reilly's early installation work was exhibited in Dublin City Gallery The Hugh Lane Gallery in 1996 under the heading 'A Silent Scream'. Included in this show was *Shame*, a mixed-media installation that articulates man's cruelty through the ritual of the bullfight. Here, an elegant picador has let his mask drop to reveal a stuffed bull's head. A blood-splattered toy-like bull lies on the ground. In the background four screens simultaneously replay the crowd's applause at the moment of a bull's death. A plaintive tune plays continuously. O'Reilly draws inspiration from a number of nineteenth-century writers, including the moralizing English poet Martin Tupper, whose work *Proverbial Philosophy* enjoyed publishing success.

In the late 1990s O'Reilly began to work in bronze in central France. Often humorous, these works are pervaded by an air of surrealism that imbues the animal figures with human characteristics. Based in Dublin, he has been commissioned to make several outdoor sculptures including *Big Bird* for temporary exhibition on O'Connell Street and *Queen Maeve* which stands on Burlington Road. He exhibits frequently in London, Paris and Amsterdam. JO'D

Kathy Prendergast
b. Dublin, 1958

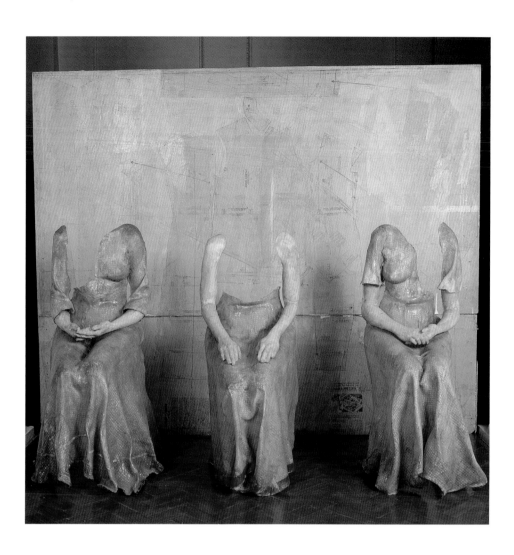

Waiting

1980
Fibreglass, resin, parquet flooring
and sewing patterns
184 × 230 cm

Purchased, 1980
Reg. No. 1449

Kathy Prendergast's work explores themes of love, death and loss through a complex variety of materials. Her unconventional juxtapositions, at times ironic, challenge our everyday associations, and it is this strangeness that resonates.

Waiting is an early work, completed during her studies at the National College of Art and Design, Dublin, for which the artist won a Carroll's Award at the Irish Exhibition of Living Art in 1980. The three seated female figures, dressed in nineteenth-century gowns, imply not only femininity but also passivity and patience, while the incomplete nature of the figures suggests a loss. The life-size figures and incorporation of real space accentuate the strangeness of the static, timeless quality of the waiting women. The dressmaking patterns traced on the wall contrast with the fitted construction of the parquet flooring below, and are further explored in the artist's later *Mapping* series.

Prendergast is considered one of the foremost Irish artists of her generation and was awarded the Premio 2000 award for Best Young Artist at the 1995 Venice Biennale. She lives and works in London.

GJ

b. Derry, 1959

At the Border II – (Low Visability)

1995
Cibachrome on aluminium
122 × 183 cm

Purchased, 1996
Reg. No. 1898

Willie Doherty is primarily a conceptual artist working mainly with photography, film and video. His work has reached a wide international audience through his having twice been a Turner Prize nominee (1994 and 2003) and through his inclusion in several biennales, most recently that at Venice in 2005. His work has consistently explored problems of representation, in particular in the context of the politics of his native Northern Ireland, and reflects upon the way in which events there have been represented in the press and media and how the image of a situation becomes the primary experience of that situation.

At the Border II – (Low Visibility) is one of a series of cibachromes that, by its title, invokes universal notions of territory and division, themes that Doherty began addressing in the 1980s. It presents a view of a gravelled road shot from a low angle from which tyre tracks wheel sharply, while in the distance are the approaching headlights of a car. The viewpoint implies an onlooker's poised presence. The low visibility rendered by the night-time light combined with the downward perspective of the image heighten its psychological charge and invoke fluctuating notions of identity and emotions that range from anxiety to fear and paranoia. Such indeterminacy is implicit in all of Doherty's work.

CK

Rita Duffy
b. Belfast, 1959

Sofa
1997
Sofa, hair pins, wax, pigment
and oil
91.5 × 162 × 88 cm
Purchased, 1998
Reg. No. 1917

As a child, Rita Duffy lived close to the Ulster Museum, and she has said that this proximity to its diverse collection was a huge influence on her becoming an artist. In 1986 she gained a Master's degree in Fine Art from the University of Ulster. While the Mexican artist Frida Kahlo and the Portuguese artist Paula Rego are among her most marked influences, Duffy's subject-matter draws heavily from the socio-political environment of Northern Ireland and is often autobiographical. Through her superb draughtsmanship and richly distinctive painterly style, she articulates and explores intense and sometimes difficult emotions. Ranging from the universal to the particular, themes such as identity, family and femininity are explored, occasionally through the symbolic language of everyday objects.

Sofa originally formed part of an exhibition of work by Duffy called 'Banquet', held at the Ormeau Baths Gallery, Belfast, in 1997 and Dublin City Gallery The Hugh Lane in 1998, which also included paintings and charcoal drawings. As on other occasions, a further layer of meaning was added through poetical collaboration. A quasi-surreal piece that plays on visual perception and assumptions, *Sofa* transforms essentially familiar and non-threatening objects – a sofa and hairclips – by combining them in an unusual way thus raising issues of territory and underlying violence.

JO'D

Close

2000
Oil on canvas
152.4 × 182.9 cm
Purchased, 2003
Reg. No. 1968

Elizabeth Magill is an innovative and compelling painter who, since the late 1990s, has used landscape as an arbitrary device, a backdrop to her thoughts on the world. Recollections of Antrim, where she was raised – the landscape of her past, as she calls it – have been significant imaginatively. At times employing various media, including photography and collage, to interplay with paint, Magill draws on a variety of images and materials ranging from contemporary kitsch to the Romantic Sublime paintings of Caspar David Friedrich to forge 'landscapes' that feel familiar but are non-specific.

Close is a depiction of an indeterminate suburb during dawn or dusk, with rhinestone stars glimmering in the sky above. Light in distant windows indicates a human presence in an otherwise remote setting. The crepuscular purple tones impair vision and create ambiguous feelings of repose and unease. Magill typically relies on chance to activate her process. Her method is to pour layer upon layer of thinly diluted paint on to the horizontally placed canvas until some clue emerges to indicate a direction. Scarring and congealed paint contribute to the emergent scenario.

Based in London since 1982, Magill came to prominence in the seminal British Art Show of 1990. An exhibition of her work was held at Dublin City Gallery The Hugh Lane in 2003.

CK

Seán Shanahan
b. Dublin, 1960

Crow
2004
Oil on MDF
240 × 210 × 5 cm
Presented, 2005
Reg. No. 1974

Seán Shanahan's rich, geometric planes of colour are tangible manifestations of the empirical world. His is a singular work, born out of the concerns of painting today. Following on from his early paintings on wood, in the early 1990s he began to work on steel, where the planes of colour extend to cover the entire surface, held in check by their horizontal and vertical format. In certain works, the smooth picture plane is scored, revealing the steel support underneath, earthing the work and nailing the colour to the surface. He is currently working on MDF, a more weighty material. The emphasis of the colour surface has shifted again. The colours no longer intersect or cohabit; the surface is now host to just one colour. The sculptural quality of the support, which hangs up to 5 cm proud of the wall, emphasizes the material existence of the colour. This corporality of colour is inherently performative in that it is realized in one hit, and once the work is negotiated, the colour plane takes on another dimension. *Crow* is one of the artist's most recent paintings. It is a painting in two parts, the dimensions of which are on a human scale, and once experienced it becomes mesmeric: the strange, intoxicating colour contained by slender margins, the chamfered edges and the narrow physical divide, echoing back to the scoring in earlier work, make it a splendid example of the mass of an object equalling the experience it expresses.

CK

*Interior Francis Bacon
Studio, 7 Reece Mews*

1998
Photograph on aluminium
122 × 152.5 cm

Purchased, 2001
© Hugh Lane Gallery and
The Estate of Francis Bacon
Reg. No. 1963

Prior to the removal of Francis Bacon's
studio from 7 Reece Mews, South
Kensington, London, photographer Perry
Ogden took a series of remarkable images
of the studio and its contents as Bacon left
them on his death in April 1992. These
images capture the unique atmosphere of
Bacon's studio and allow one to explore the
artist's private space where he lived and
worked for more than thirty years. They are
not simply documentary images but have
an aesthetic beauty in their own right. With
great intimacy, Ogden captures every detail
of the studio including the torn photographs,
precarious piles of books, magazines and
newspapers, the paint-encrusted walls and
even the layer of dust on the shelves
beneath the mirror.

Perry Ogden grew up in London and
became interested in photography while
still at school. He worked as a fashion
photographer for a number of years. His first
exhibition at Dublin City Gallery The Hugh
Lane was entitled 'Pony Kids' and focused
on the cultural phenomenon of children
keeping ponies on patches of green in
the wastelands of some of Dublin's most
deprived areas. Ogden has also had success
as a film-maker, and his first film, *Pavee
Lackeen* (2005), met with much critical
acclaim. He lives and works in Dublin.

MC

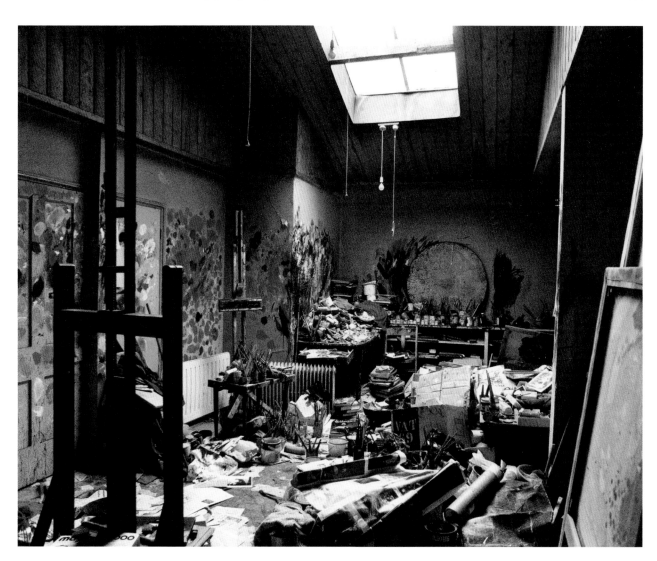

Mark Francis
b. Newtownards, County Down, 1962

Recoil
1997
Oil on canvas
214 × 214 cm

Purchased, 1998
Reg. No. 1953

Mark Francis is fascinated by the natural sciences. His studio could be mistaken for a laboratory with its images of plant, animal and human cells and their circulatory networks, as well as his collection of diagrams and illustrations of various fungi and skin disorders. He is one of a number of artists of his generation for whom the electron microscope and advances in telescopic technology have provided a hitherto unavailable repertoire of images. This material forms an integral part of the artist's life and provides the inspiration for his paintings.

Recoil arises out of works of the early 1990s in which networks of spores and sperm are painted with a limited palette and in a way that pitches the seductive qualities

of paint against the objectivity of scientific observation. Painted 'wet on wet', the resulting blur of the sperm-like forms suggests movement beyond the usual creative associations, a claustrophobic sense of genesis out of control, especially resonant in an age of genetic engineering and biological warfare. The grid, upon which *Recoil*'s imagery floats, began to appear in Francis's work in the mid-1990s. Its presence reflects the artist's interest in man-made systems as notional arbitrators between order and chaos, and posits his art in the context of Modernist abstraction.

CK

b. Dublin, 1966

It is the indefinable fragmented nature of the human condition, overheard conversations and casual incidents that inform the haunting work of Jaki Irvine. Her single and multiple screen projections avoid linear narrative, and instead exploit discontinuities between musical score, moving image and narrator.

Ivana's Answers, filmed in Prato, Italy, centres on the conversation between two women. As one reads the tea leaves of the other's cup, questions emerge around the nature of perception, memory, estrangement and desire. The conversation is broken by views of a hazy park, falcons and insects, as time folds back into itself (appearing almost static) and then forward again. Irvine rejects the manipulative strategies of conventional cinema, distancing what is seen and what is heard, thus unsettling the viewer into a place somewhere between the two. Half-remembered dream-like moments resonate in the mind of the viewer, undermining certainty and allowing thoughts to wander, personal histories to be replayed, and new and alternative histories imagined.

After graduating from the National College of Art and Design, Dublin, in 1989, Irvine completed a Master's degree in Fine Art at Goldsmith's College, London, in 1994. She has exhibited widely, notably at the Venice Biennale, in the exhibition of Young British Artists, 'General Release', in 1995 and representing Ireland in 1997, and at Tate Britain.

GJ

Ivana's Answers

2001
DVD projection
10 minutes

Purchased, 2005
Reg. No. 1976

Oliver Comerford

b. Dublin, 1967

Dwelling Series I–V

1996
Oil on board
Each 29.2 × 44.4 cm

Purchased from Hallward Gallery,
Dublin, 1996
Reg. No. 1889

Oliver Comerford studied art in London and Dublin, citing among his influences American social realist painters such as John Sloan (1871–1951), photography and film. He travelled frequently between Ireland and the US during the 1990s, visiting downtown areas in cities such as Detroit, which heightened his awareness of the urban environment. His work frequently evokes our modern experience of urban space, through which we often travel at such speed that we have little time to register our surroundings.

Dwelling Series I–V has a cinematic quality suggested by the ordering of the five paintings into a single, horizontal sequence. It recalls the road movie, yet the 'journey' remains incoherent. Links between specific paintings are implied by common subject-matter or handling, but Comerford deliberately leaves ambiguous the mode of transport and specific locations, encouraging us to engage with more universal ideas of motion and transience in the urban landscape. As in many of his paintings, the subject-matter of *Dwelling Series I–V* draws on the thousands of photographs he has taken over the past twenty years. His use of board as the support, to which oil paint is thinly applied, results in an emphatically flat surface, further recalling the photographic image.

JS

Why it's time for Imperial, again

1998–2002
DVD, 25 minutes, documentation
consisting of five photographs
(each 2002 Fuji crystal archive
print, 53 × 63 cm)

Purchased, 2005
Reg. No. 1988

Gerard Byrne explores the technology of
representation and its pivotal impact on
cultural history. His work, primarily
photography and film, questions the
construction of reality, concurrently
questioning the strategies and desires
of representation.

Why it's time for Imperial, again restages
and replays a fictional conversation between
the iconic figure of Frank Sinatra and Lee
Iacocca (then chairman of Chrysler)
discussing the new Chrysler Imperial.
The reference for this conversation was
an 'advertorial' in *National Geographic*,
November 1980. The film follows the
conversation from derelict urban space to
freeway, seedy diner to toilets, a far cry
from the glossy car showroom. The script
is played out again and again, reiterating
the pitch to a capitalist consumerist society.
Yet disjunctions and faltering lines again
contradict the 'text', the photographs of the
advertisement shown in the installation
and the stacks of magazines. By employing
documents from the recent past, Byrne
questions and unravels both past and
current suppositions, the real and the
representation.

Byrne has exhibited widely, including
at Manifesta 4, Frankfurt, 2002, and the
Istanbul Biennale, 2003. He studied at the
National College of Art and Design, Dublin,
and completed a Master's degree in Fine Art
at the New School for Social Research, New
York and subsequently the Whitney
Independent Study Program in 1999.

GJ

Niamh O'Malley
b. Mayo, 1975

The dene 'vignette'
2004
Oil on canvas and
DVD projection
140 × 245 × 450 cm

Purchased, 2005
Reg. No. 1987

Contemporary Irish artist Niamh O'Malley explores the disparity between representational devices such as painting and video and the understanding they propose.

In *The dene 'vignette'* the image is constructed through the precise alignment of a projected image and its painted counterpart. The fixed vantage-point of a quiet corner in New York's Central Park is represented, in which the stillness of the generic scene of grass, trees and lamppost is interrupted by passing pedestrians, park life and distant traffic. The work references the notion of the landscape as a framing device, inherent in the history of Central Park itself, which was based on the famous *Greensward Plan* and begun in 1857. A momentary lapse in the projected image reveals the empty painted canvas and, with it, the artifice. The incorporation of the projected image and painting not only acknowledges the notion of the representation of representation but also queries real-life perception. O'Malley has said of the work: "it can be read as a slowly moving painting producing a visual tension between the still, painted landscape and the real-time filmic space."

O'Malley completed a doctorate at the University of Ulster, Belfast, in 2003 and the P.S.1 Centre for Contemporary Art residency in New York in 2004, where this work was produced.

GJ

b. County Antrim, 1975

Screen
2005
DVD
Purchased, 2005
Reg. No. 1981

Since 1998, Matt Calderwood has been making installation and video works that are as much about sculpture and the material conditions of the world as they are related to performance or film. He sets up controlled situations that test the properties of certain materials as well as his own physical and mental endurance. His sometimes panic-inducing, often humorous videos challenge our perception of the material world.

Screen was specially made for projection on a wall in Dublin City Gallery The Hugh Lane and fits its dimensions exactly. Typical of Calderwood's work is the element of surprise, and a tendency to play with the viewer's expectations. The piece begins with the illuminated wall accompanied by the

ambient sound of birdsong. Two metal forms begin to tear through the wall and raise it to reveal a band of green grass beneath. As the wall continues to retreat upwards it becomes apparent that the artist is driving a tractor and reversing with the wall impaled on its forklift, replacing what we thought was the gallery wall with a view of the countryside.

Calderwood was included in the group show 'Clarke & McDevitt Present' at Dublin City Gallery The Hugh Lane in 2005, and *Screen* was a site-specific piece for that exhibition. Calderwood has also had solo projects with Tate Britain and the David Risley Gallery.

CK

Bruce Arnold, *William Orpen, Mirror to an Age*, London (Jonathan Cape) 1981

Bruce Arnold, *Mainie Jellett and the Modern Movement in Ireland*, London and New Haven CT (Yale University Press) 1991

Jonathan Benington, *Roderic O'Conor: A Biography with a Catalogue of His Work*, Dublin (Irish Academic Press) 1992

Thomas Bodkin, *Hugh Lane and his Pictures*, Dublin (The Arts Council) 1956

Margarita Cappock, *Francis Bacon's Studio*, London and New York (Merrell Publishers) 2005

Ciaran Carty, *Robert Ballagh*, Dublin (Magill) 1986

David Carrier, *Sean Scully*, London (Thames & Hudson) 2004

Bernard Champigneulle, *Rodin*, London (Thames & Hudson) 1980

Ian Chilvers, *A Dictionary of Twentieth-Century Art*, Oxford (Oxford University Press) 1998

Nicola Dearey and John O'Regan, *Micheal Farrell, Profile 9*, Kinsale (Gandon Editions) 1998

Brian Ferran, *Basil Blackshaw – Painter*, Belfast (Nicholson & Bass) 1995

R.F. Foster, *W.B. Yeats: A Life*, 2 vols., Oxford (Oxford University Press) 1997–2003

Ellen R. Goheen, with photographs by Wolfgang Volz, *Christo: Wrapped Walkways, Loose Park, Kansas City, Missouri 1977–78*, New York (Harry N. Abrams) 1978

Nicola Gordon Bowe, 'The Bird in the Work of Niki de Saint Phalle', *Irish Arts Review Yearbook*, 1988, pp. 3–36

Nicola Gordon Bowe, *The life and work of Harry Clarke*, Dublin (Irish Academic Press) 1989

Enrique Juncosa (ed.), *Irish Museum of Modern Art: The Collection*, Dublin (Irish Museum of Modern Art) 2005

Raymond Keaveney *et al.*, *National Gallery of Ireland, The Essential Guide*, London (Scala Publishers) 2002

S.B. Kennedy, *Irish Art & Modernism 1880–1950*, Belfast (Institute of Irish Studies, The Queens University of Belfast) 1991

Christopher Lloyd, *Pissarro*, London (Macmillan) 1981

Brian Lynch, *Tony O'Malley*, Aldershot (Scolar Press in association with Butler Gallery, Kilkenny) 1996

Elizabeth Mayes and Paula Murphy (eds.), *Images and Insights*, Dublin (Hugh Lane Municipal Gallery of Modern Art) 1993

Daniel J. Murphy (ed.), *Lady Gregory's Journals*, vol. 2, Books Thirty to Forty-Four, 21 February 1925 – 9 May 1932, afterword by Colin Smythe, Gerrard's Cross (Colin Smythe) 1987

Patrick Murphy, *Patrick Tuohy, from conversations with his friends*, Dublin (Townhouse) 2005

Perry Ogden, with a foreword by John Edwards, *7 Reece Mews, Francis Bacon's Studio*, London (Thames & Hudson) 2001

Hilary Pyle, *Jack B. Yeats: A Catalogue Raisonné of the Oil Paintings*, 3 vols., London (Deutsch) 1992

Hilary Pyle (ed.), *Deborah Brown: From Painting to Sculpture*, Dublin (Four Courts Press) 2005

Robert O'Byrne, *Hugh Lane, 1875–1915*, Dublin (The Lilliput Press) 2000

Medb Ruane, *Alice Maher, Profile 6*, Kinsale (Gandon Editions) 1998

Theo Snoddy, *Dictionary of Irish Artists – 20th Century*, Dublin (Wolfhound Press) 1996

Dorothy Walker, with a foreword by Seamus Heaney, *Modern Art in Ireland*, Dublin (The Lilliput Press) 1997

James White, *Gerard Dillon*, Dublin (Merlin Publishing) 1993

Exhibition catalogues

Alice Maher 'Familiar', by Alice Maher, Dublin, Douglas Hyde Gallery; Belfast, Orchard Gallery, January–February 1995

Anne Madden, Trajectories 1995–1997, by Aidan Dunne, Dublin, The Hugh Lane Municipal Gallery of Modern Art, November 1997

Banquet, Rita Duffy, by S.B. Kennedy and Suzanne O'Shea, Belfast, Ormeau Baths, August–September 1997; Dublin, The Hugh Lane Municipal Gallery of Modern Art, February–April 1998

Beyond the White Cube, A retrospective of Patrick Ireland/Brian O'Doherty, ed. Elizabeth Mayes, Dublin, Dublin City Gallery The Hugh Lane, March–June 2006

Brian Maguire, 'Inside/Out', by Valerie Connor *et al.*, Dublin, The Hugh Lane Municipal Gallery of Modern Art, January–March 2000

Burne-Jones and His Followers, by John Christian, venues throughout Japan, 1987

A Century of Irish Painting, by Yasushi Asakawa and Barbara Dawson, Hokkaido, Mitaka and Yamanashi, 1997

Dorothy Cross, by Enrique Juncosa *et al.*, Dublin, Irish Museum of Modern Art, June–September 2005

Edward and Nancy Kienholz 'The Merry-Go-World or Begat by Chance and the Wonder Horse Trigger'

by Edward Kienholz and Nancy Reddin Kienholz, Houston, Moody Gallery, September–October 1992

The Edwardians, Secrets and Desires, by Anne Gray *et al.*, Canberra, National Gallery of Australia, March–June 2004; Adelaide, Art Gallery of South Australia, July–September 2004

Familiar Alice Maher, essay by Fionna Barber, Dublin, Douglas Hyde Gallery; Belfast, Orchard Gallery, January–March 1995

F.E. McWilliam, by Judy Marle and T.P. Flanagan, Belfast, Dublin and Cork, 1981

F.E. McWilliam Sculpture 1932–1989, by Mel Gooding, London, Tate Gallery, May–July 1989

Francis Bacon in Dublin, by David Sylvester *et al.*, Dublin, The Hugh Lane Municipal Gallery of Modern Art, June–August 2000

Frank O'Meara and his contemporaries, by Julian Campbell, Dublin, Cork and Belfast 1989

The Irish Impressionists, by Julian Campbell, Dublin, National Gallery of Ireland, October–November 1984; Belfast, Ulster Museum, February–March 1985

Irish Women Artists from the Eighteenth Century to the Present Day, intro. by Anne Crookshank, Dublin, National Gallery of Ireland; Trinity College; Douglas Hyde Gallery; Hugh Lane Municipal Gallery of Modern Art, July–August 1987

Janet Mullarney, The Perfect Family, by Paul O'Reilly, Dublin, Hugh Lane Gallery, November 1998 – January 1999

John Singer Sargent, ed. Elaine Kilmurray and Richard Ormond, London, Washington, D.C. and Boston 1999

Josef Albers – Small Paintings, essay by Michael Craig-Martin, London, Waddington Galleries, April–May 2004

Joyce in Art: Visual Art inspired by James Joyce, Christa-Maria Lerm Hayes, Dublin, Royal Hibernian Academy, June–August 2004

Knot, Alice Maher draws from the collection of the Hugh Lane Municipal Gallery of Modern Art, by Alice Maher, Dublin, The Hugh Lane Municipal Gallery of Modern Art, April–June 1999

Louis le Brocquy, by Anne Crookshank and Jacques Dupin, Dublin, Municipal Gallery of Modern Art; Belfast, Ulster Museum, 1966–1967

Louis le Brocquy, Paintings 1939–1996, intro. by Alistair Smith, Dublin, Irish Museum of Modern Art, October 1996 – February 1997

Micheal Farrell: a monograph, by Cyril Barrett, Dublin, Douglas Hyde Gallery, April–May 1979

Monet in the Twentieth Century, by Paul Hayes Tucker and Mary Ann Stevens, Boston, Museum of Fine Arts, September–December 1998; London, Royal Academy of Arts, January–April 1999

Nathaniel Hone, by Julian Campbell, Dublin, National Gallery of Ireland, June–August 1991

Patrick Graham – The Lark in the Morning, essays by John Hutchinson, Donald Kuspit, Peter Murray, Dublin, Douglas Hyde Gallery; Cork, Crawford Municipal Art Gallery, 1994

Patrick Scott, A Retrospective, by Ivonne Scott *et al.*, Dublin, Hugh Lane Gallery, February–April 2002

Paul Henry, by S.B. Kennedy, Dublin, National Gallery of Ireland, February–May 2003

Paul Klee, by K. Koutsomallis *et al.*, Andros, Museum of Modern Art, Basil and Elise Goulandris Foundation, June–September 1993

Paul Klee, Centenary, London, Fischer Fine Arts Ltd, July–August 1979

Philip Guston, Retrospective, by Michael Auping *et al.*, Fort Worth, San Francisco, New York and London 2003–04

Pierre Puvis de Chavannes, by Aimée Price Brown, Amsterdam, Van Gogh Museum, February–May 1994

Recent Works by Michael Mulcahy, Do-gong series, by Pascal Bonafoux and Barbara Dawson, Dublin, The Hugh Lane Municipal Gallery of Modern Art, July–August 1997

Rita Duffy, 'Banquet', by Suzanne O'Shea, Belfast, Ormeau Baths Gallery, August–September 1997; Dublin, Hugh Lane Gallery, February–April 1998

Roderic O'Conor, Vision and Expression, by Roy Johnston, Dublin, Hugh Lane Gallery, 1996

Sean Shanahan, 'Vidar', by Mel Gooding *et al.*, Dublin, The Hugh Lane Municipal Gallery of Modern Art, September 2002 – January 2003

A Silent Scream – Recent Works by Patrick O'Reilly, essay by Mark Glazebrook, Dublin, The Hugh Lane Municipal Gallery of Modern Art, 1996

Walter Osborne, by Jeanne Sheehy, Dublin, National Gallery of Ireland, 1984

When Time Began to Rant and Rage, Figurative Painting from Twentieth-Century Ireland, ed. James Steward, Liverpool, Berkeley, New York and London 1998

William John Leech, by Denise Ferran, Dublin, Quimper and Belfast, March 1997

Willie Doherty: False Memory, by Carolyn Christov-Bakargiev and Caoimhin MacGiolla Leith, Dublin, Irish Museum of Modern Art, October 2002 – March 2003

Yeats: Portrait of an Artistic Family, by Hilary Pyle, Dublin, National Gallery of Ireland, 1997

First published 2006 by Merrell Publishers Limited

Head office
81 Southwark Street
London SE1 0HX

New York office
49 West 24th Street, 8th floor
New York, NY 10010

www.merrellpublishers.com

In association with
Dublin City Gallery The Hugh Lane
Charlemont House
Parnell Square North
Dublin 1

www.hughlane.ie

British Library Cataloguing in Publication Data
Dublin City Gallery : the Hugh Lane
 1.Hugh Lane Municipal Gallery of Modern Art – Catalogs
 2.Painting – Ireland – Dublin – Catalogs
 I.Cappock, Margarita
 708.2'91835

ISBN 1 85894 333 7

Produced by Merrell Publishers
Designed by Dennis Bailey
Copy-edited by Catherine Blake

Printed and bound in China

Cover:
Sean Scully
Figure in Grey, 2004
Oil on canvas, 299.7 × 256.5 cm

Back cover:
Elizabeth Magill
Greyscale (2), 2005
Oil on canvas, 137 × 168 cm

Page 2:
Francis Bacon
Untitled (Elongated Walking Figure), c. 1949
Oil on canvas, 152 × 116 cm

Page 8:
Jack B. Yeats
The Maggie Man, 1912
Oil on panel, 35.5 × 22.9 cm